DRUMLINE TECHNICAL MANUAL

JOHN PARKER

Drumline Technical Manual

John Parker

Copyright © 2014 by Phatman Drums

All rights reserved. This book or any portion thereof may not be reproduced or used in any manner whatsoever without the express written permission of the publisher except for the use of brief quotations in a book review or scholarly journal.

First Printing: 2014

ISBN 978-1-312-66347-3

Phatman Drums
4634 E Willow Point Ct
Wichita, KS 67220

phatmandrums.com

Ordering Information:

Special discounts are available on quantity purchases by corporations, associations, educators, and others. For details, contact the publisher at the above listed address. U.S. trade bookstores and wholesalers: Please contact Phatman Drums Tel: (316) 734-2574 or email john@phatmandrums.com.

Dedicated to Jan Verboom and Ray James who guided me through my first experiences in the athletic musical arts.

Table of Contents

Playing Techniques .. 9
- Snare Drum .. 11
- Bass Drum .. 13
- Tenors .. 14

Exercises .. 17
- Legato 8's .. 18
- Chex Mix .. 20
- Tap Accent .. 22
- Shifting Accents .. 24
- Triple Strokes .. 28
- Duple Diddle .. 30
- Triplet Diddle .. 32
- Triplet Rolls .. 34
- Flams .. 36
- Mouthful .. 38
- ParaTrooper .. 42
- Diddle Groove .. 44
- Gear Shift .. 46
- Sequel .. 48
- Stupid Left Hand .. 50

Cadences .. 53
- Oscar .. 54
- Neverland .. 56
- The Remix .. 58

Solos .. 60
- Velvet .. 61
- backbeat .. 62
- For a Lifetime .. 64

Appendix .. 66
- Stroke definition Worksheet .. 67

Playing Techniques

The Three Methods of Motion

As we strike the drum(s) with the stick, we have three muscle groups we can use, each with their own advantages and disadvantages:

1. **Arms** (anything above the wrist including forearm, elbow, and shoulder): Arms are good for slow, loud playing. Obviously arms have the biggest muscles out of the three options, but they're bulky and sluggish.
2. **Wrist:** The main driver of motion in drumming, wrists offer a balance between speed and volume. In matched grip, the wrist moves vertically, as if knocking on a door. The left hand in traditional grip rotates as if turning a doorknob.
3. **Fingers**: The smallest muscle group, fingers can play the fastest, but not at very loud dynamics.

Developing strength and quickness in each muscle group is imperative to good drumming. After all, most drumming applications require players to use all the muscle groups interchangeably.

Stroke Definitions

While not always an active thought in a drummer's head during playing, an understanding of the following stroke types is essential to executing any rudimental playing.

1. **Legato Stroke**: A smooth, flowing motion that starts high above the drum, travels downward to strike the drum, and finishes at its original position high above the drum. This stroke is also called a Full Stroke.
2. **Staccato Stroke**: Comprised of the first half of the Legato Stroke. It starts high above the drum but stops just after hitting the drumhead, at a low height above the drum. Think of it like catching the stick just after it produces a sound on the drum. This stroke is also called a down stroke.
3. **Up Stroke**: The second half of the Legato Stroke. It starts low above the head, makes a short downward motion to strike the drum, and then is brought back up above its original height, much higher above the drum. While the most awkward of the four stroke types to master by itself, it is the most vital as it sets up the player to execute either a Legato or a Staccato stroke.
4. **Tap Stroke**: A very low stroke that starts and finishes at the same low point off the drum. Taps typically require more control to play and thus may require the use of more wrist than fingers. However, faster passage will force the player to open up the hand and let the fingers do more work. Finesse is the name of the game!

For extra practice, see the Stroke Definition Supplemental Worksheet at the end of this book.

Dynamics

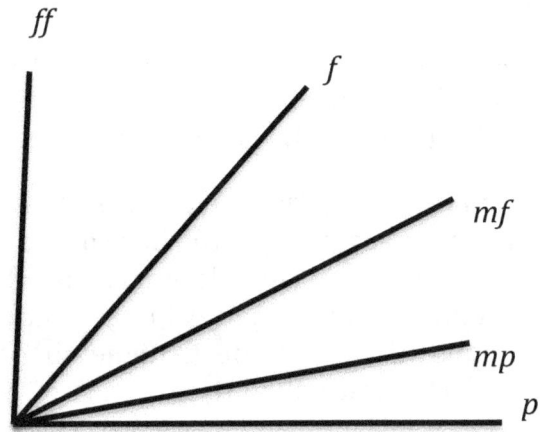

ff	12"	Full wrist turn
f	9"	¾ wrist turn
mf	6"	½ wrist turn
mp	3"	¼ wrist turn
p	1 ½"	Drop from playing position

Instrument Specific Techniques

Snare Drum

Set position
Sticks held in both hands one to two inches above the drum and away from carrier. Shoulders relaxed, eyes forward.

Playing position
Sticks out at roughly an 80 degree angle, with the sticks at even angles, pointing down roughly 10 degrees. The sticks rest about an inch and a half above the center of the drum.

Notation

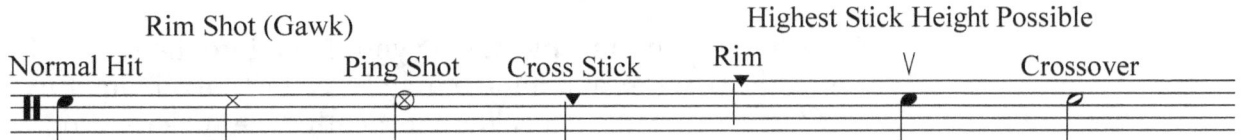

TRADITIONAL GRIP (optional, if using matched grip refer to the right hand technique and apply it to the left hand)

RIGHT HAND: To set the grip, start by hanging your hand freely at your side. Next, bend the elbow so that the forearm is at roughly parallel to the ground with the palm down.

The grip itself is formed by placing the stick across the palm at such an angle that the stick passes under the base of the index finger and the bottom of the palm. The fulcrum is made by pinching the stick with the thumb and index finger. The other three fingers wrap around stick for support. Remember that all four fingers remain on the stick at all times.

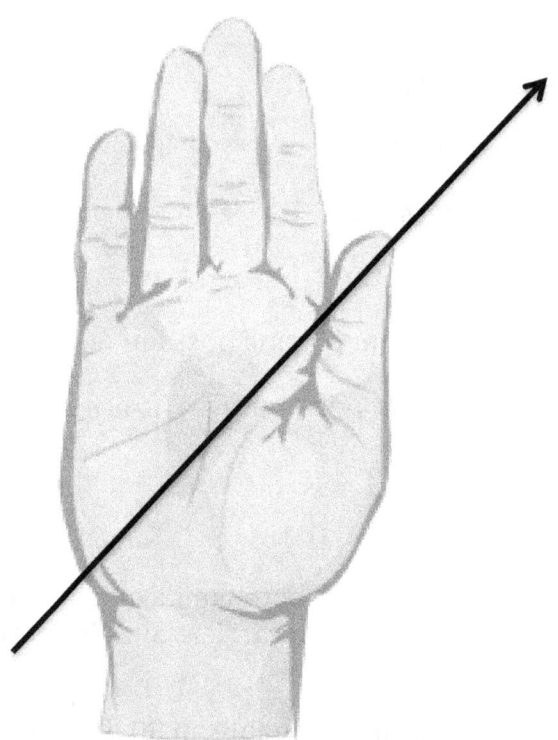

LEFT HAND: Again start with the hands at your side, then bend the elbow so your hand is parallel to the ground. The palm should be facing inward, like you're going to shake hands.

To form the grip, start by making your hand into the shape of a gun with the index and middle fingers as the "barrel" and the ring finger and pinkie curled underneath. The stick rests on top of the ring finger and on the padding between the thumb

and the top of the hand. The "barrel" of the gun wrap over the stick. Finally, the thumb forms the fulcrum of the grip by touching the top knuckle of the pointer finger. (It can be tempting to release the thumb at louder dynamics, but doing so should be avoided at all costs.)

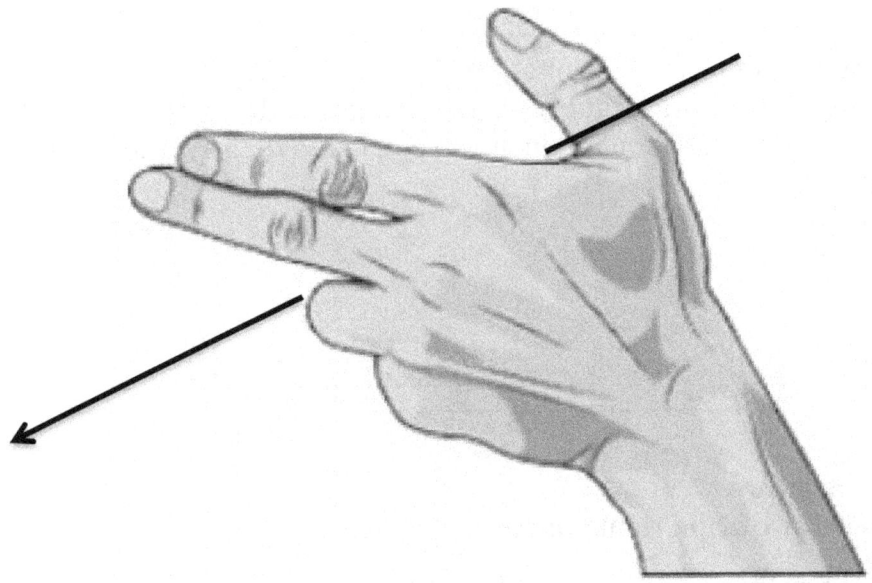

Bass Drum

Set Position
Mallets straight vertical, chest high against the rim of the drum. Shoulders relaxed, eyes toward the sideline / instructor.

Playing Position
Arms relaxed with the forearms extended parallel to the ground. The head of the mallets should rest directly in the middle of the drum about an inch and a half above the head.

Notation

Matched Grip
See snare drum right hand.

To adopt this technique to the bass drum, simply rotate the hands until they are perpendicular with the ground. The same height system and stroke definitions apply.

Be sure to hit the drum dead center to avoid tonal discrepancies.

Tenors

Set Position
Shoulders relaxed, eyes forward. Sticks at the sides pointing directly towards the ground.

Playing position
Sticks out directly in front of the player, resting over drums one and two, with the sticks at even angles, pointing down roughly 10 degrees. The sticks rest about an inch and a half above the center of the drum.

Notation

Matched Grip
See snare drum right hand.

Playing zones:
In order to accomplish good sound quality it is important to strike the heads close to the edge, similar to timpani playing. The following playing positions should serve as a good guide:

MOVEMENT:

It is important to move around the drums in as much of a straight line as possible. Doing so decreases the amount of effort required to get from one drum to another, thus making it easier to play faster. Motion is initiated with a rotation from the elbows. In some extreme cases it may be necessary to follow through with the arms, but that should be avoided if possible. The waist and shoulders should never be used as a source for movement (practicing with stands will tempt you, but you must resist).

CROSSOVERS

ADJACENT DRUMS: When crossing between two touching drums (1 & 2, 1 & 3, 2 & 4), don't over extend. Cross the sticks only, just past the fingers. Crossing any more than that will drive the sticks out of the playing zones.

NON-ADJACENT DRUMS: Crossing by skipping drums (2 & 3, 1 & 4) will require the player to cross at the wrists. But again, be very careful not to over extend.

Remember, when moving from drum to drum, whether crossing over or not, use the minimal amount of effort possible. And stay relaxed!

Here it is, another drumline book full of exercises to develop your rudimental chops and some cadences and solos to show off your hard work. These are the exercises I've always used with the drumlines I've coached. You'll find the basics like Legato 8's and Double Strokes along with some advanced technique exercises for specific situations. Each exercise has specific notes for work with a full drumline along with notes for individual players.

Exercises

Legato 8's

Drumline:

The most basic exercise in the book is also the most important. 8's works on numerous technical concepts: timing across the line, single strokes, movement across the tenor drums, and simple runs up and down the bass line.

Be sure to work the exercise not only at multiple tempos, but at multiple dynamics as well (including crescendos and decrescendos).

The trickiest part of this exercise is the exchange from one hand to the next. Watch out!

Individuals:

This one's all about speed! Remember to relax and let the wrist and fingers do all the work. If you're playing this on tenors, be sure to isolate the up and down motion of the wrists from the side-to-side motion generated from the arms. Remember: the wrist/fingers propel the sticks up and down; the arms move the wrist from drum to drum.

Just like when working with a group, be sure to work at multiple dynamics as well as tempos.

Goals

1. Stay relaxed
2. Strive for consistent sound from hand to hand
3. Push your tempos

60 bpm	80 bpm	100 bpm	120 bpm	140 bpm	160 bpm	180 bpm	200 bpm	220 bpm	240 bpm

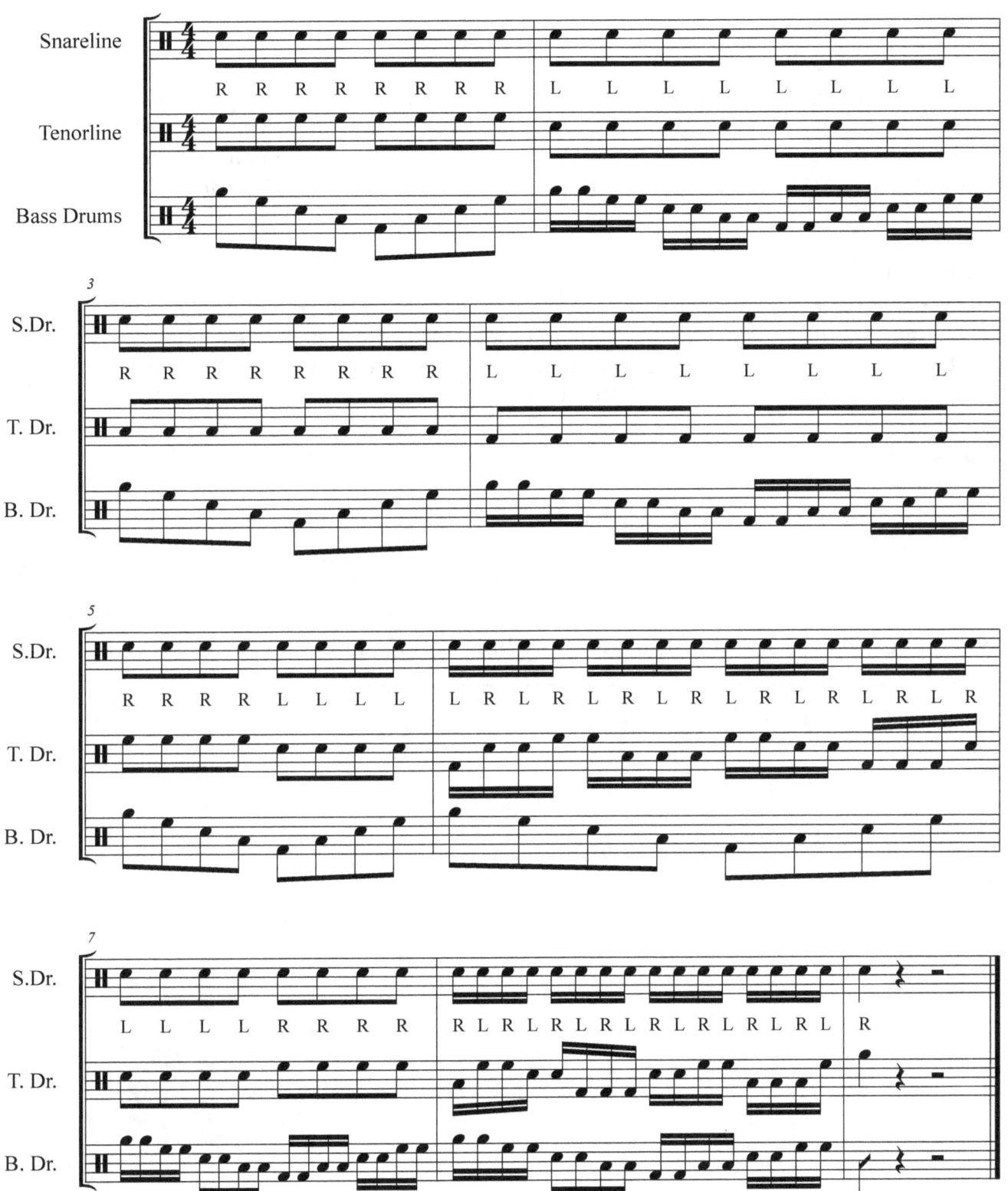

Chex Mix

Drumline:

Sticking with one-height concepts, Chex Mix will work the ensemble's interpretation of 16th notes and rhythmic placement. While the exercise is written unison, you can always have different sections start at different phrases for some variety. It's also beneficial to have two sections play a constant check (just 16th notes), while the remaining section plays the exercise.

Individuals:

Set your metronome to play the 16th note check and then try to "clean" your playing with the met. You should also try setting the met to only play the down beat of each bar, or feel the met as playing the up-beat 8th notes instead of quarter notes. For the individual, this one's all about accuracy and feeling a consistent tempo.

Goals

1. Stay relaxed
2. Strive for consistent sound from hand to hand
3. No accents

60 bpm	80 bpm	100 bpm	120 bpm	140 bpm	160 bpm	180 bpm	200 bpm

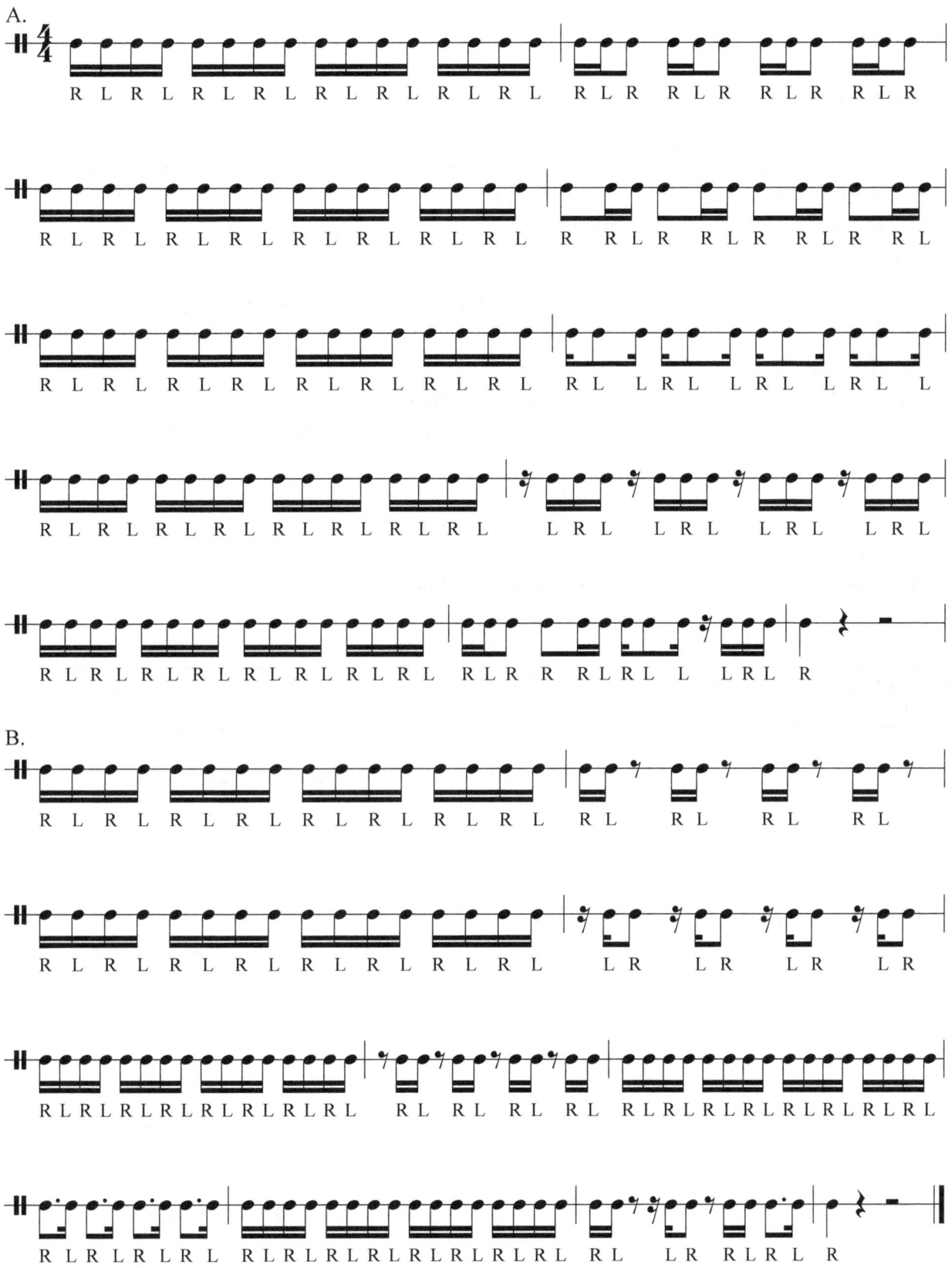

Tap Accent

Drumline:
Now we move into the area of two-height playing. The key here is to control the rebound after each accent so that the stick remains low for the following taps (unaccented notes). To accomplish this, the player will need to use a staccato stroke based entirely in the wrist. However, remember that each consecutive note at the same height should be treated as legato strokes.

Again, be sure to vary the overall dynamics of the ensemble while you work this exercise.

Individuals:
Concentrate on the contrast between the accent and the tap, especially at faster tempos. Practicing this one in the mirror will help to ensure consistent stick heights throughout the exercise.

Goals
1. Control the rebound
2. Strive for maximum contrast between taps and accents

60 bpm	80 bpm	100 bpm	120 bpm	140 bpm	160 bpm	180 bpm	200 bpm

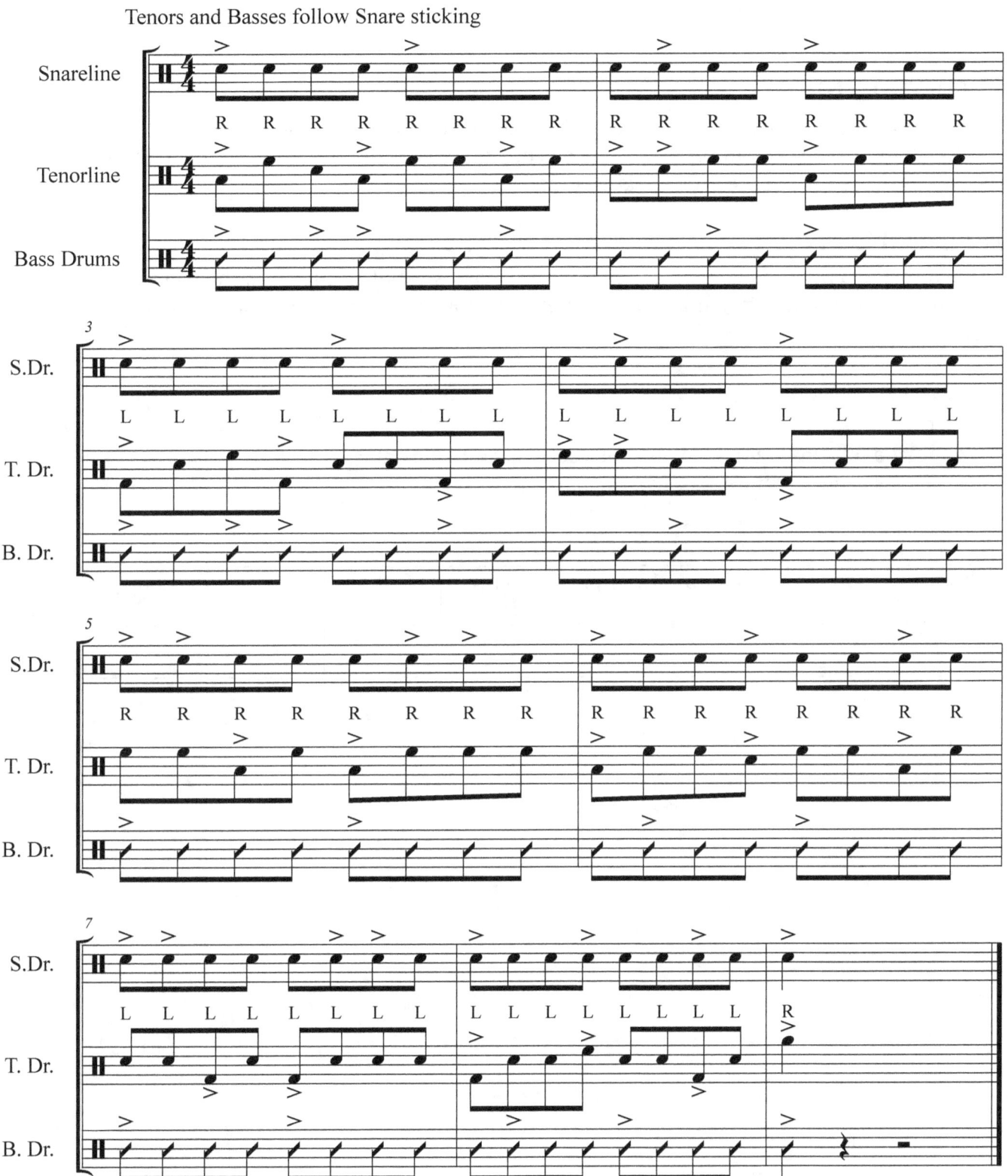

Shifting Accents

Drumline:

Once the line locks in with Tap Accent, it's time to start applying the same concepts in hand-to-hand patterns. This one has a nice groove and is really good to get the feet moving. Listening across during the unisons is an must!

Individuals:

As we move to a hand-to-hand exercise be sure to pay special attention to the sound quality between the right and left hands. Also, be very cautious not to pulse the beat as you play this one.

Goals

1. Control the rebound
2. Strive for maximum contrast between taps and accents
3. Perfect the 16th note timing

60 bpm	80 bpm	100 bpm	120 bpm	140 bpm	160 bpm	180 bpm	200 bpm

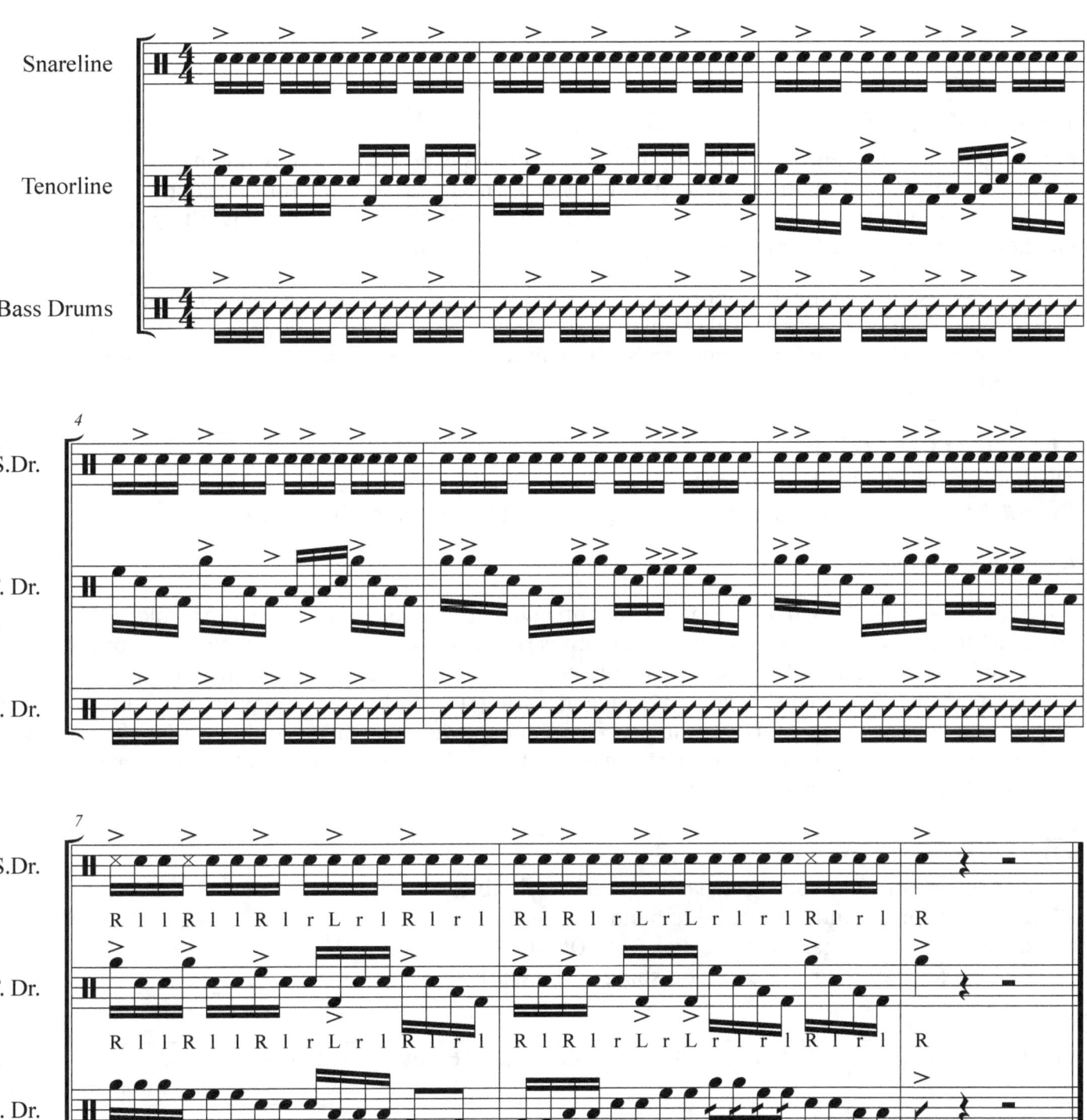

Double Strokes

Drumline:

Most high school drumlines will spend more time on this exercise than they do on any other. Developing and maintaining consistently clean doubles is a must for any good drumline. Be sure to watch for even stick heights and level dynamics from player to player. Most of all beware of players using accents or bounces to achieve their doubles.

The exercise is written for the tenors to use sweeps across the drums. Be very sure that each player is using the wrist to play down to the drum and the arm to move the wrist from drum to drum. The default voicings can be difficult for young players. Feel free to simplify the pattern as needed.

Individuals:

The key to good doubles is to treat them like two quick legato strokes, never like an open "buzz." Be sure not to overplay the first note in an effort to "force" the double.

As always, start slow!

Students love to ask "at what tempo do you stop using your wrist to generate the stroke and start to just let the stick bounce." The truth is that the premise of the question is wrong. We never just let the stick bounce, that would result in weak floppy doubles. Instead, the issue is a matter of when do we switch from generating the stroke from the wrist to letting fingers become the driving force in the process. That answer is a matter of chops and tempo. Generally, I say to let your wrist drive the stick as long as possible, but somewhere around 140 bpm, the fingers start to take over.

Goals

1. Consistent sound between each note of the double
2. Consistent sound from hand to hand
3. Wrist or finger generated stokes, NO BOUNCES!
4. Relaxed hands, let the drum do some of the work.

60 bpm	80 bpm	100 bpm	120 bpm	140 bpm	160 bpm	180 bpm	200 bpm

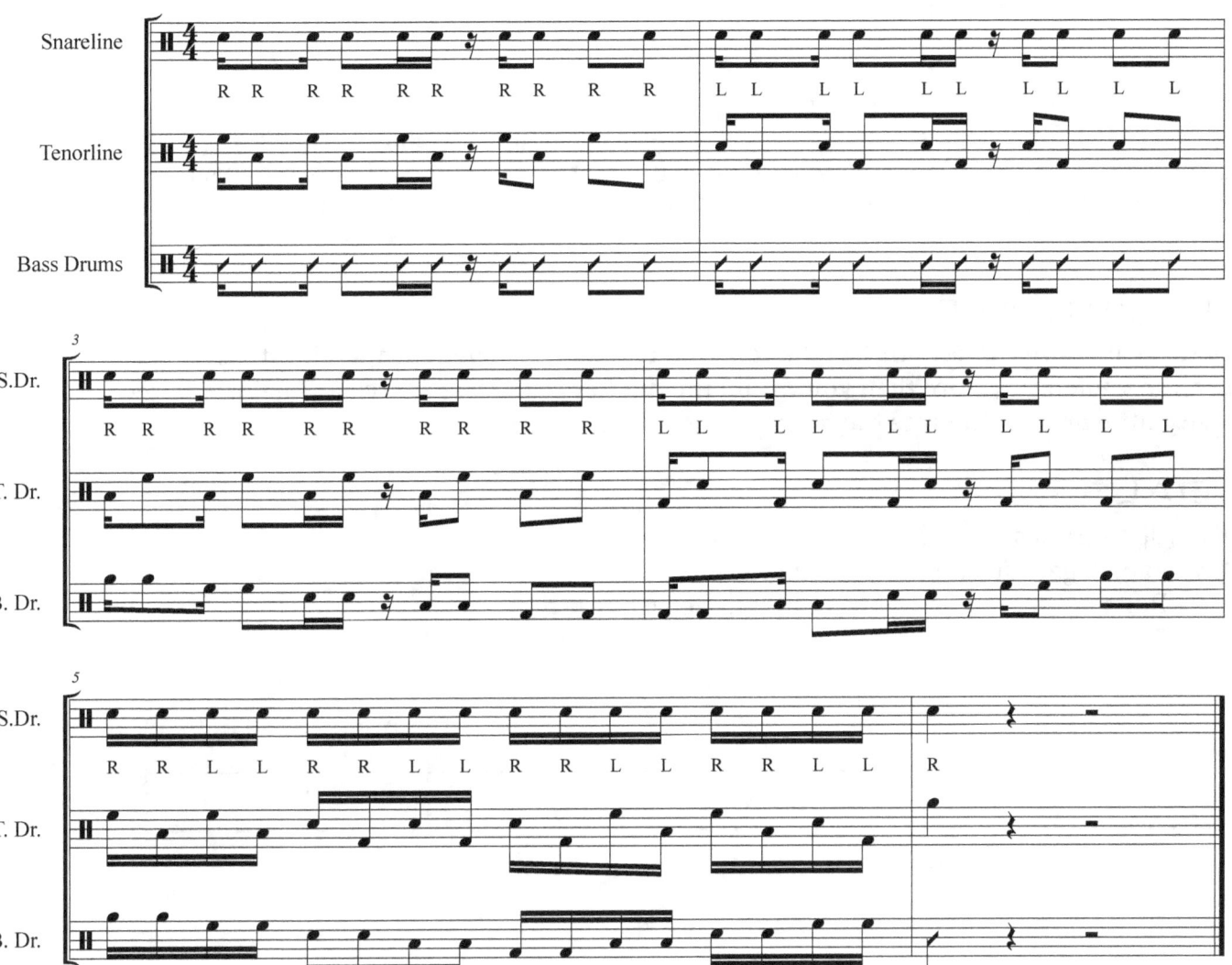

Triple Strokes

Drumline:
Triples are the final basic stroke type we're going to develop. So many of the flam rudiments rely on this. The trick will be lining up the triple-stroked triplets of the snares and tenors against the single-stroked triplets of the basses. Take it slow and let it come to you.

Individuals:
Legato strokes are the key. Utilize the rebound and let the fingers propel the stick. Don't crush the triplets anymore than you would the diddles in the last exercise. Again, feel free to use a little arm to generate the force for the initial stroke.

Goals
1. Open triples, don't crush them!
2. Even legato strokes throughout
3. Don't accent the first note, don't let the last note die.

60 bpm	80 bpm	100 bpm	120 bpm	140 bpm	160 bpm	180 bpm

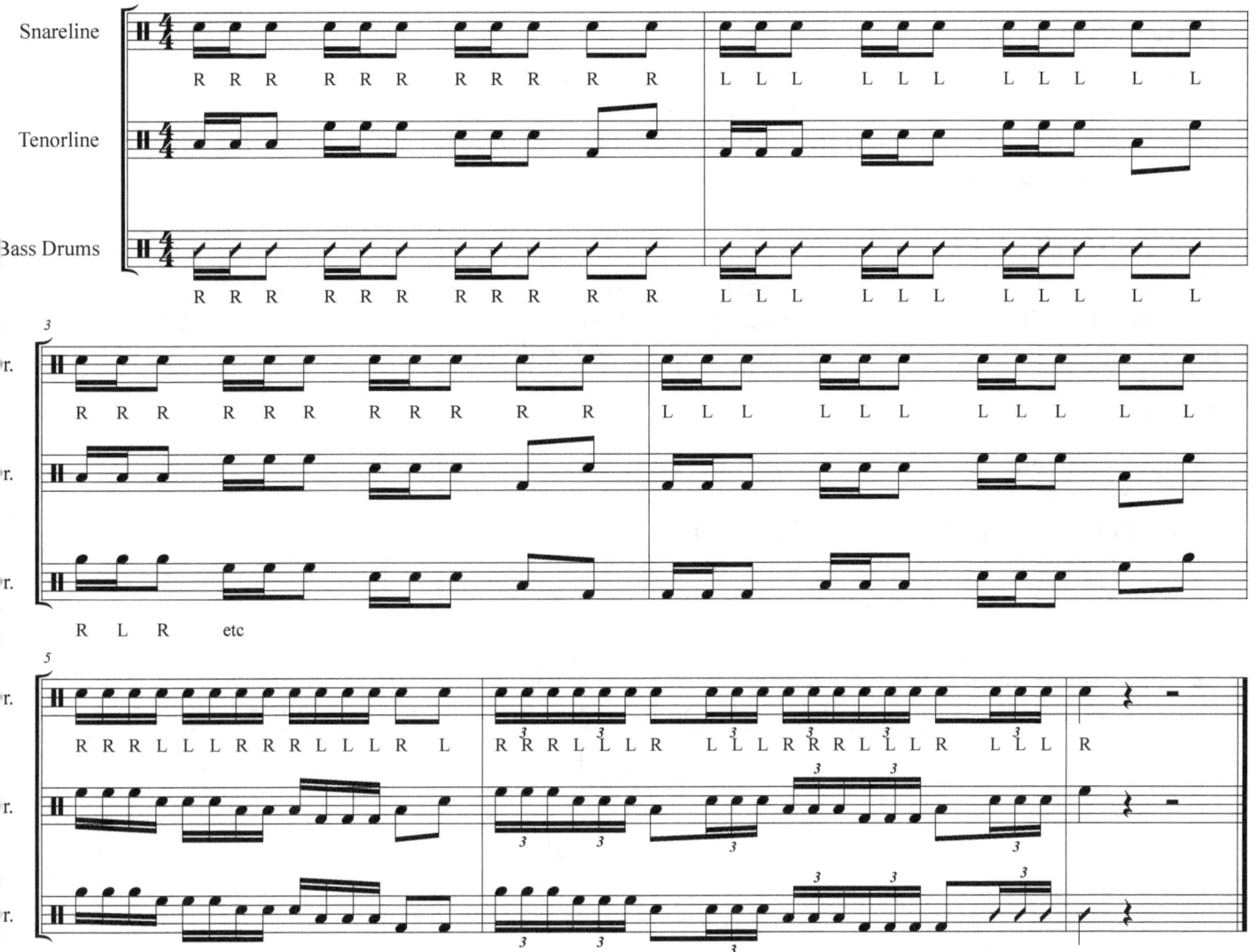

Duple Diddle

Drumline:
Once the line is playing clean doubles, you can start to move to work on diddle interpretation. Beyond obviously playing nice, open diddles, don't overlook the check in the first two beats. Good clean 16th notes are vital for the interpretation of the diddle in the second half of each bar.

Individuals:
This is the first time when it becomes acceptable to use a little bit of arm. One or two diddles are easily achieved with just the wrist/fingers. But at higher tempos, a little extra push from the forearm helps to propel the stick into the diddles.

Goals
4. Consistent 16th note / 32nd note interpretation
5. No accents
6. Consistent sound from hand to hand
7. Wrist or finger generated stokes, NO BOUNCES!

60 bpm	80 bpm	100 bpm	120 bpm	140 bpm	160 bpm	180 bpm	200 bpm

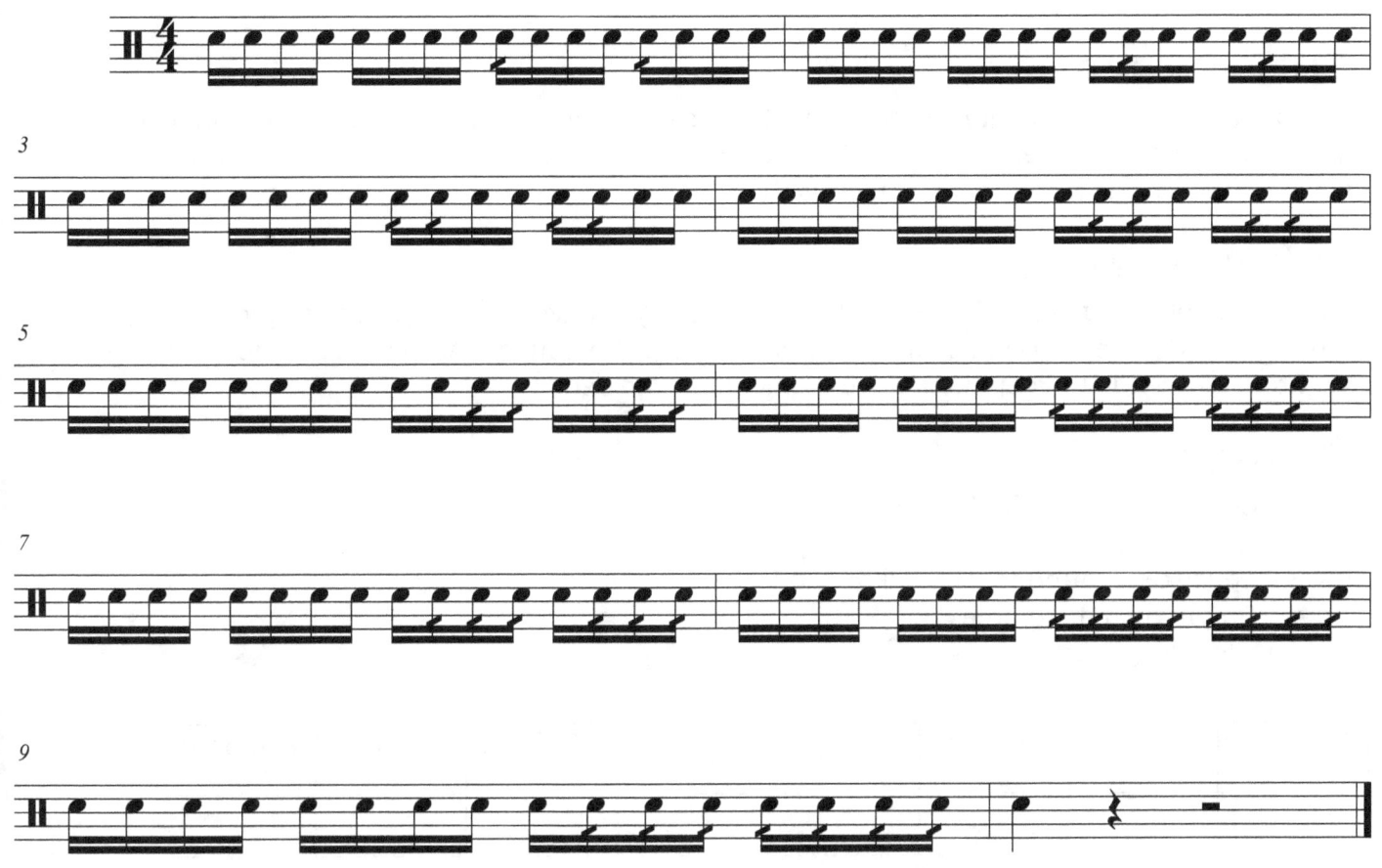

Triplet Diddle

Drumline:
In modern literature, triplet rolls are almost more common than duple rolls. So spend just as much time on this exercise as you do on Duple Diddle, if not more. Triplet rolls, while a slower subdivision, present challenges as the sticking changes on each down beat.

Individuals:
Be careful not to crush the diddles on this one. Always strive for a smooth sextuplet interpretation, free of accents. Also, try "leaning into" the longer rolls by giving them the slightest crescendo to keep them from dying out at the end.

Goals
1. Consistent sextuplet interpretation
2. No accents
3. Consistent sound from hand to hand
4. Don't crush the diddles

60 bpm	80 bpm	100 bpm	120 bpm	140 bpm	160 bpm	180 bpm	200 bpm

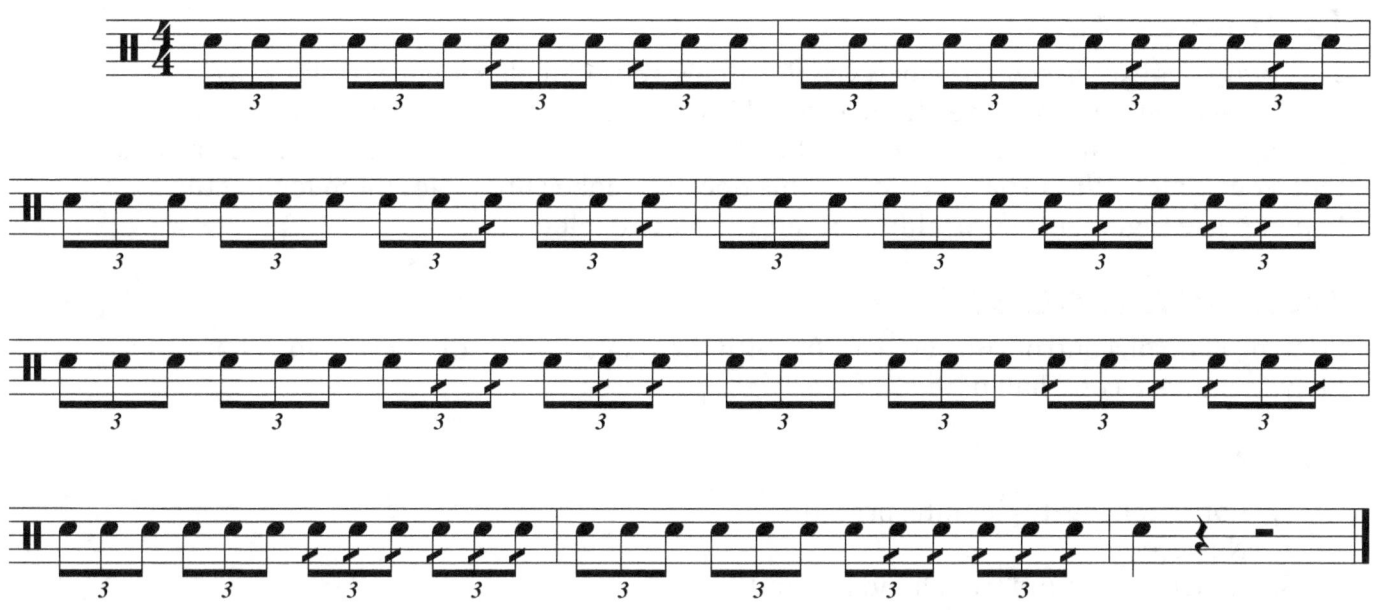

Triplet Rolls

Drumline:
This two-part exercise will really work the 'line's ability to play longer triplet rolls. One good idea to get this exercise off the ground is to leave out the diddles and just work on playing clean dynamics. Once the stick heights are lining up, add the diddles back in. Also take your time with the bass drums on this one and make sure to get them feeling the triplet pulse together before adding in the 16th note triplets.

Individuals:
Control, control, control. Be very careful with the quality of the diddles as you change heights in the second half of this exercise.

Goals
1. Consistent sextuplet interpretation
2. No accents
3. Consistent sound from hand to hand
4. Don't crush the diddles
5. Good sound quality throughout the dynamic changes

60 bpm	80 bpm	100 bpm	120 bpm	140 bpm	160 bpm	180 bpm	200 bpm

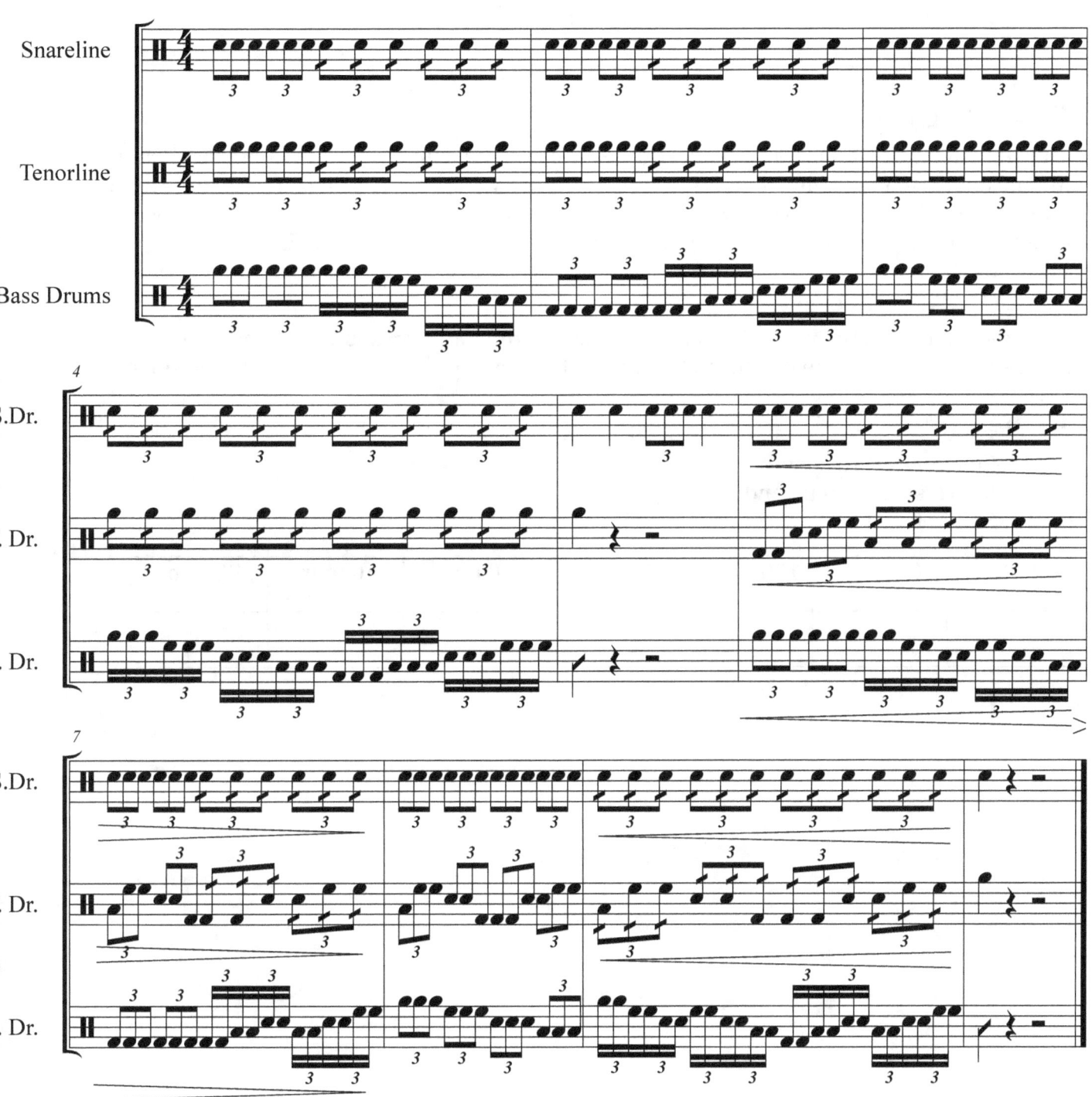

Flams

Drumline:
This one's a stock model, utilitarian exercise – no frills, no chills. But don't underestimate it! The ability to play uniform flams across the line is vital for modern drumline literature. The tendency of all the players will be to tighten up their grip to better control the grace notes. Instead, strive to relax throughout the whole exercise and let the flams flow!

Individuals:
The grace notes are the key to this exercise. Strive for a uniform sound between each hand's flams. Control the heights in the last section and don't let the grace notes creep up.

Goals
1. Control the grace note
2. Match sound from hand-to-hand
3. Stay relaxed.

60 bpm	80 bpm	100 bpm	120 bpm	140 bpm	160 bpm	180 bpm

Tenors and Basses follow Snare sticking

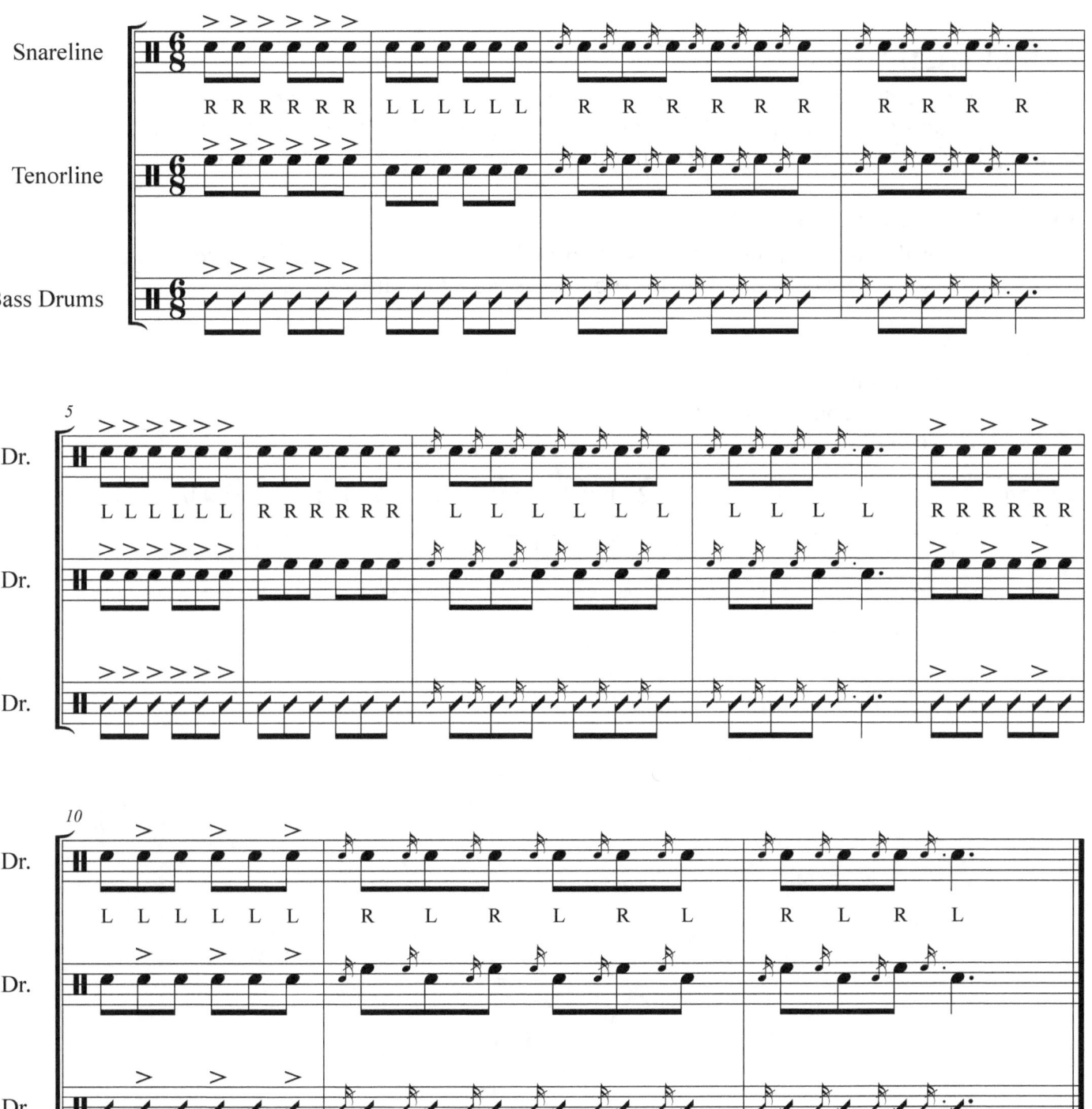

Mouthful

Drumline:
Probably the hardest exercise in this book, Mouthful works on the major flam rudiments (flams, flam accents, flam taps, and flam drags) while giving the bass drums some fun work splitting triplets. There's a lot going on in this one, hence the name... Mouthful.

Individuals:
This one takes all the techniques we've used up to this point. Take it easy, stay relaxed and have fun. This one gets better and better the more speed you can add!

Goals
1. Control the grace note
2. Match sound from hand-to-hand
3. Stay relaxed.

60 bpm	80 bpm	100 bpm	120 bpm	140 bpm	160 bpm	180 bpm

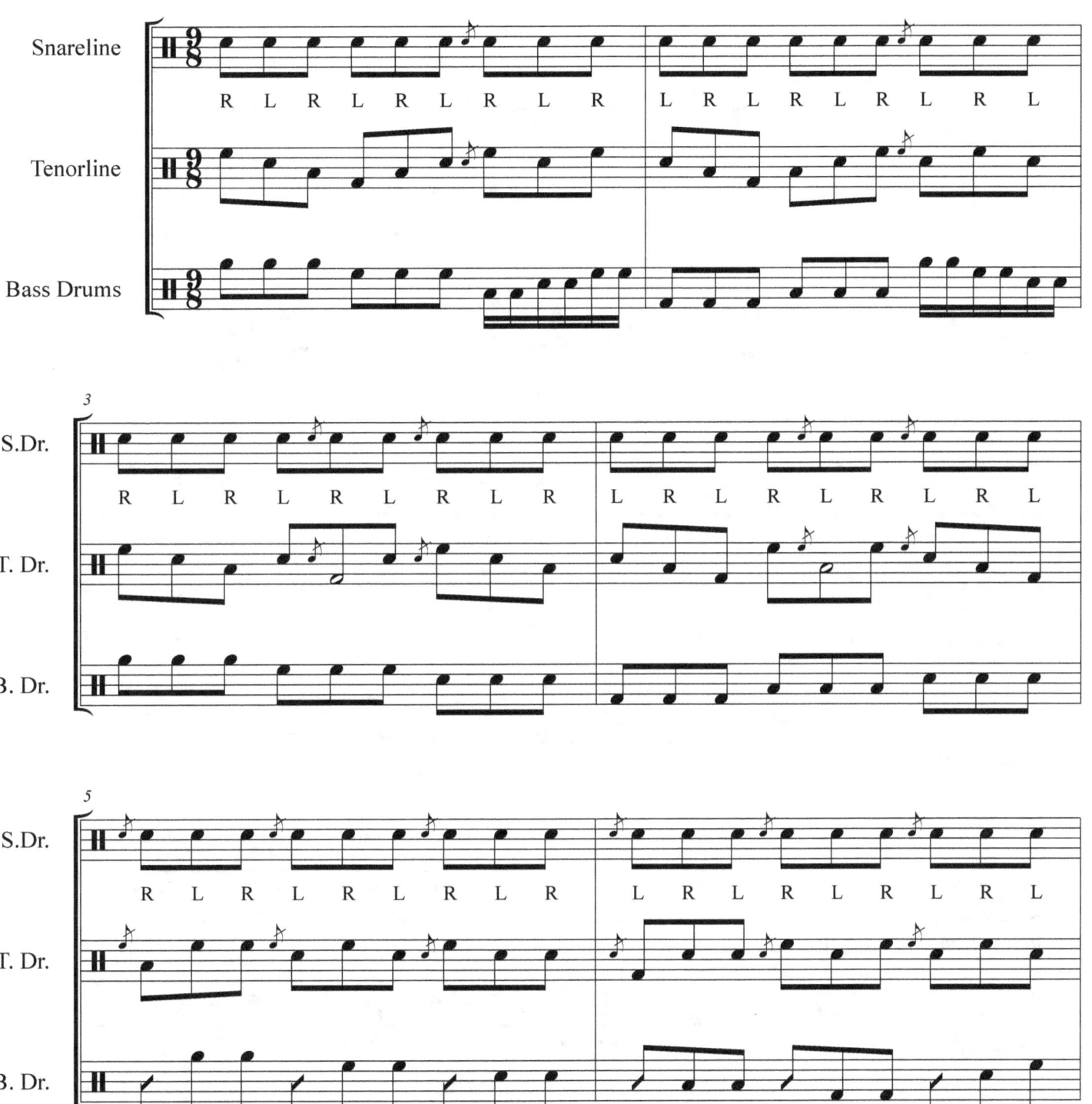

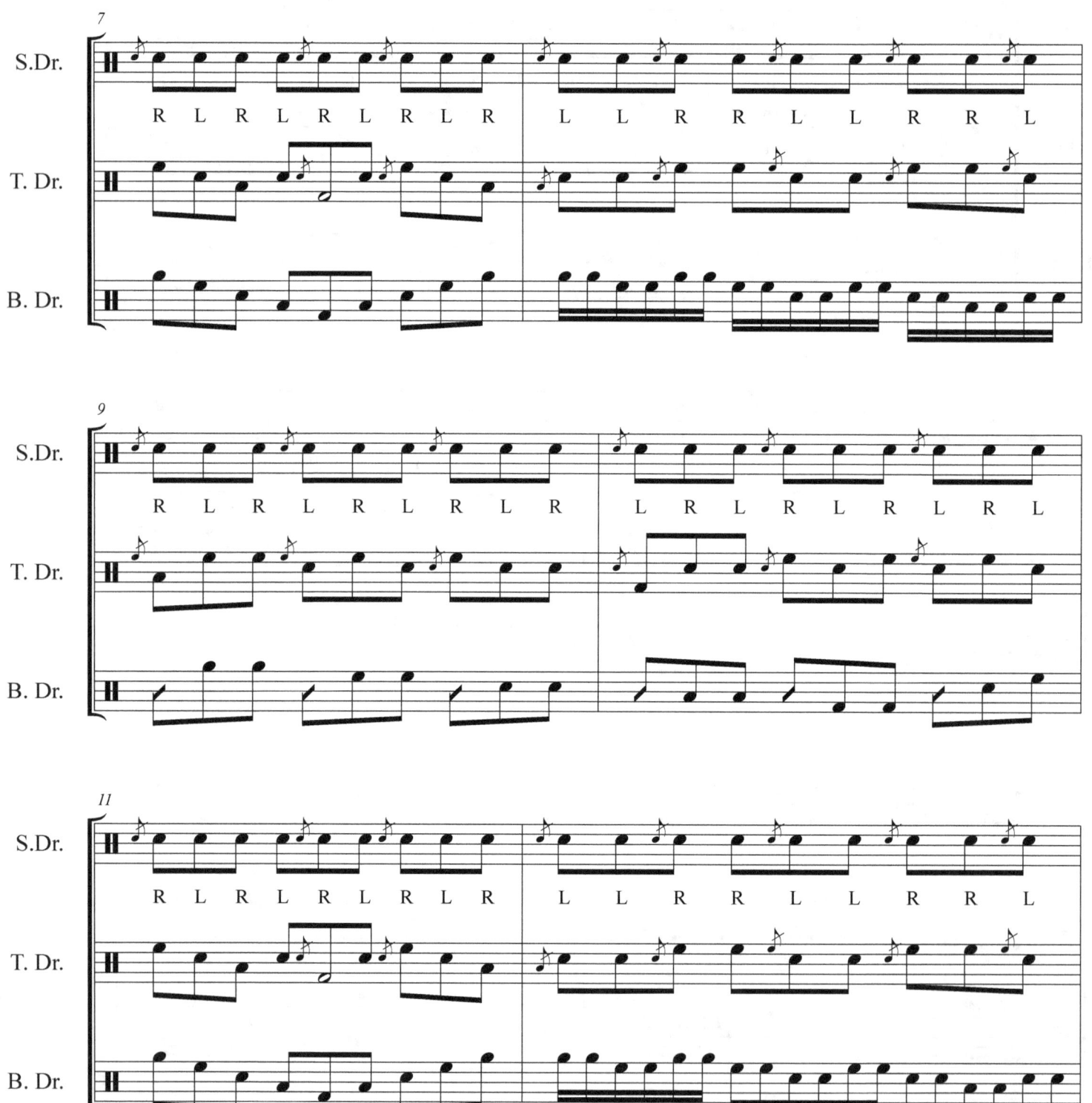

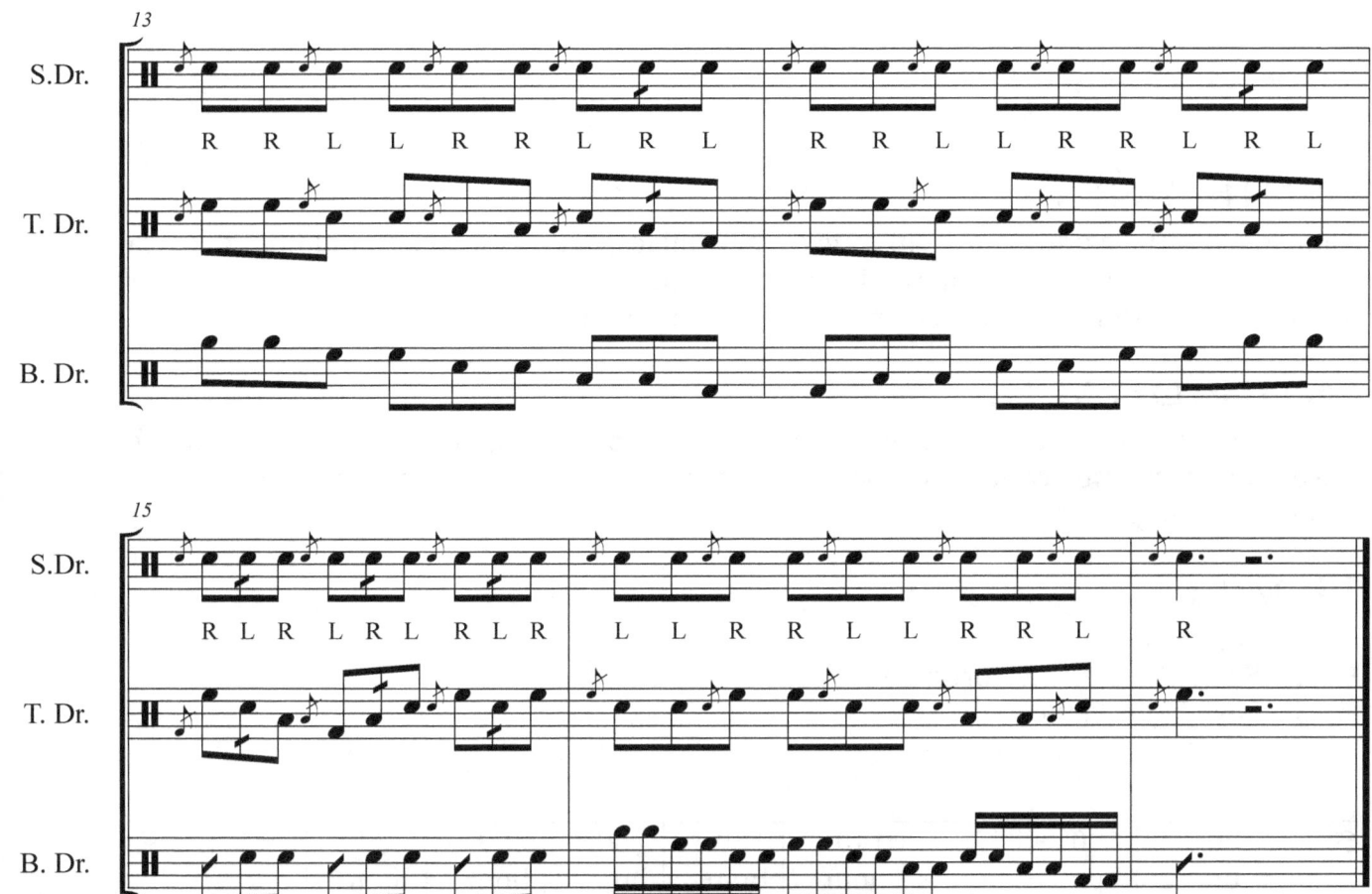

ParaTrooper

Drumline:
Time to work the paradiddles. This one covers singles, doubles, and paradiddle-diddles on each hand. Meanwhile, bass one and two are having some fun working splits while the rest of the basses outline the skeletal structure of the paradiddles.

Individuals:
Be sure to maintain a consistent 16th note interpretation throughout the exercise. Don't let the diddles rush. Meanwhile, use good accent technique to keep the taps clear and the accents popping.

Goals
1. Pop the accents
2. Even 16th note interpretation
3. Push your tempos

60 bpm	80 bpm	100 bpm	120 bpm	140 bpm	160 bpm	180 bpm	200 bpm	220 bpm	240 bpm

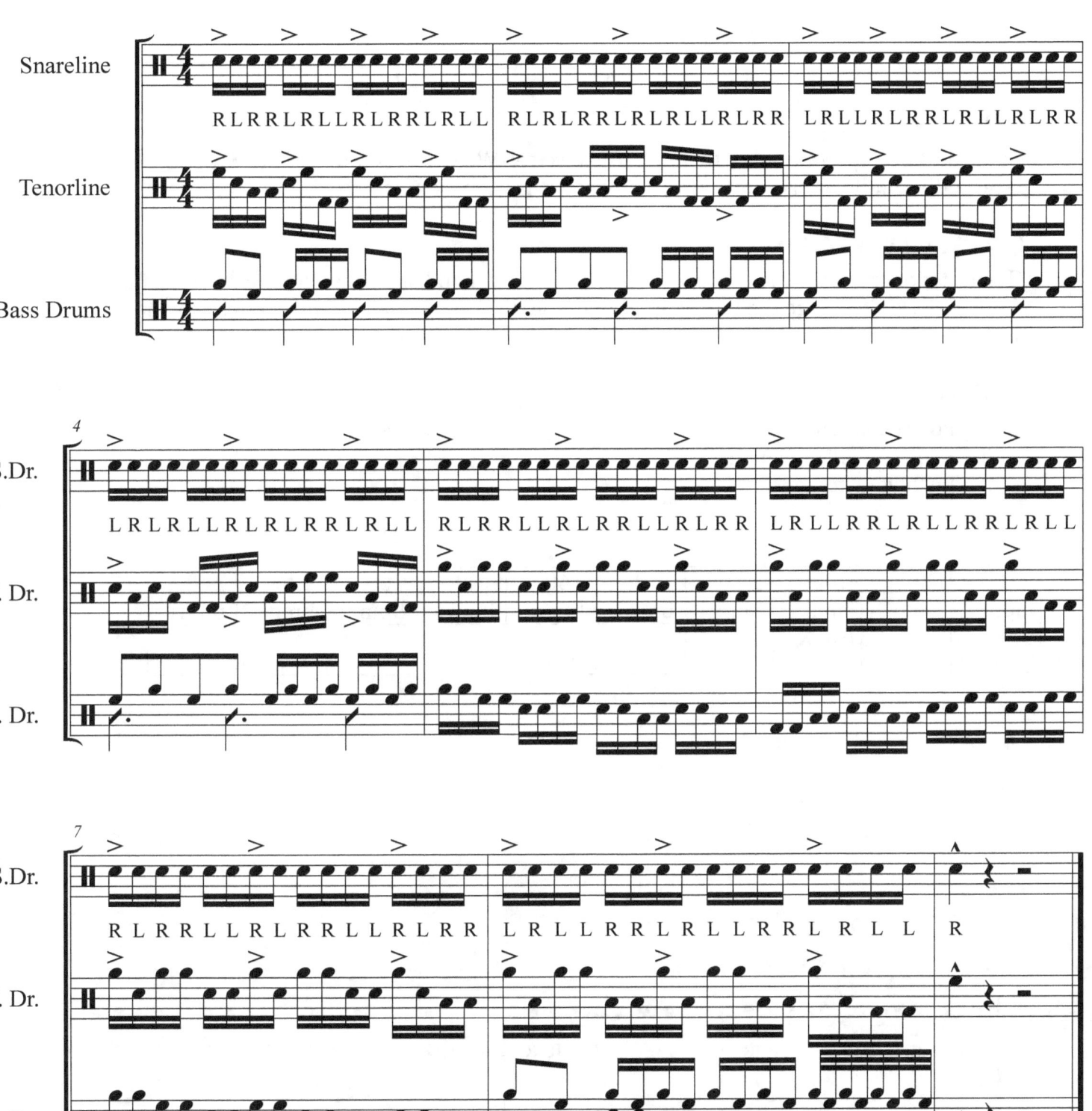

43

Diddle Groove

Drumline:
The drumlines I've worked with love this exercise! We were having trouble with paradiddle-diddle interpretation, so I devised this little exercise. Make sure it grooves!

Individuals:
The first 4 bars are the most important! Set the right-hand, and then don't let the left hand change it! Don't change the interpretation of the diddles as you go! Keep 'em open and tripletish!

Goals
1. Pop the accents
2. Keep the diddles open
3. Push your tempos

60 bpm	80 bpm	100 bpm	120 bpm	140 bpm	160 bpm	180 bpm	200 bpm	220 bpm	240 bpm

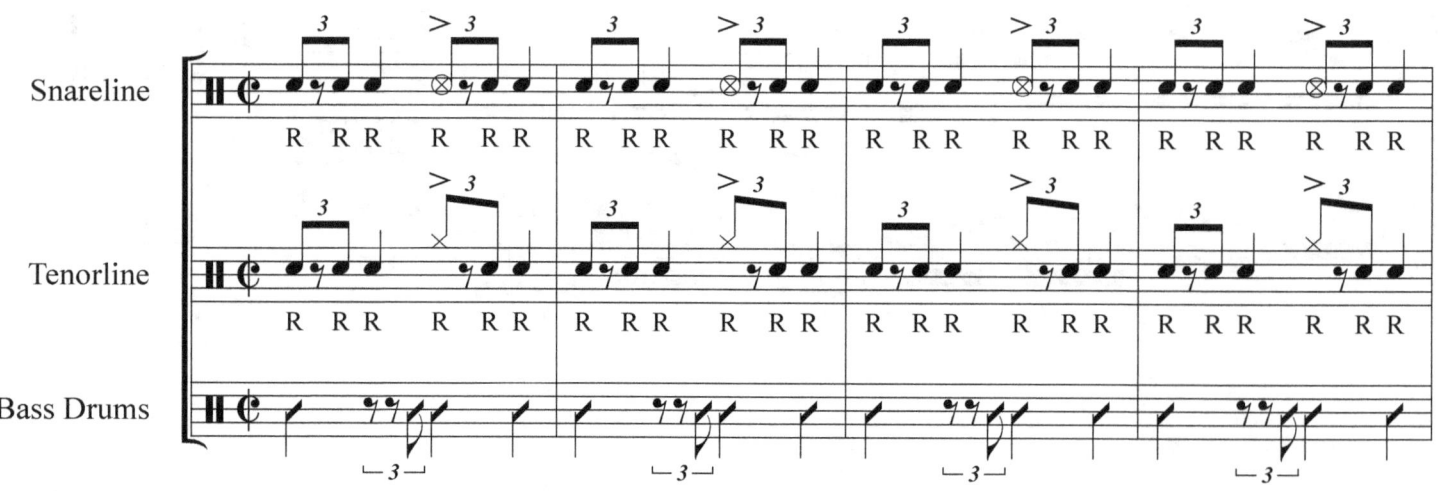

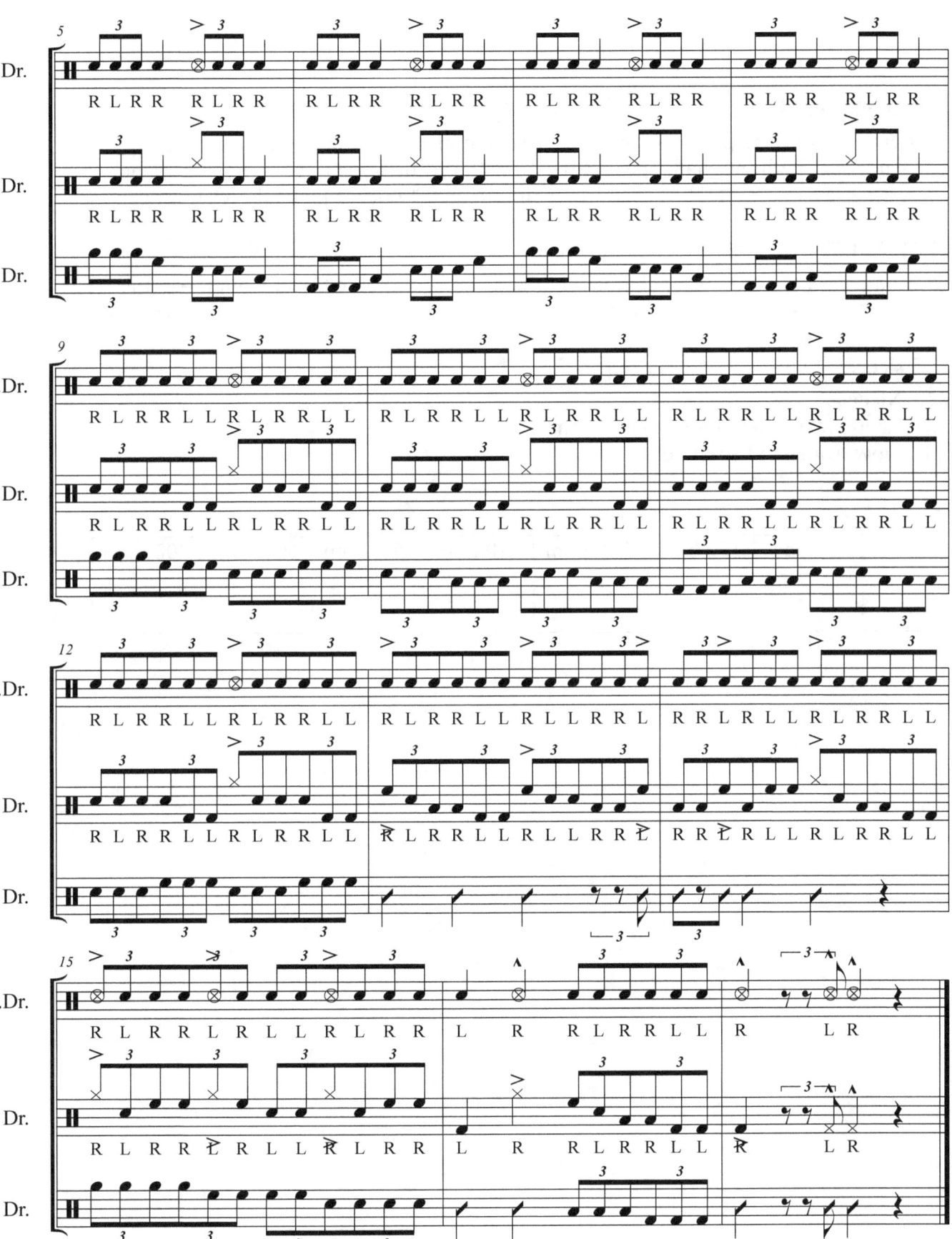

Gear Shift

Drumline:
In modern literature, triple to duple shifts are common place. To help the drumline approach those rhythmic challenges I came up with this little exercise. The quarter-note triplets are the biggest pit fall. Be sure they fit into an 8th-note triplet subdivision.

Individuals:
Metronome is a must for this one! Keep it flowing and subdivide throughout the entire exercise.

Goals
1. No accents
2. Keep the quarter-note triplets in time
3. Flow from hand-to-hand

60 bpm	80 bpm	100 bpm	120 bpm	140 bpm	160 bpm	180 bpm	200 bpm

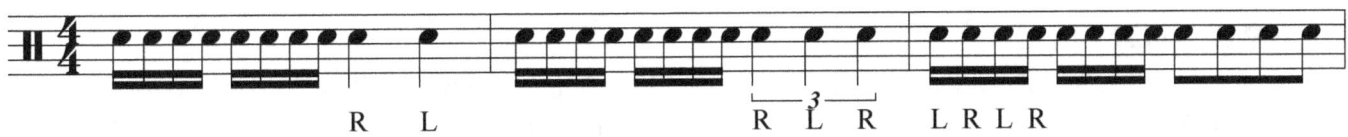
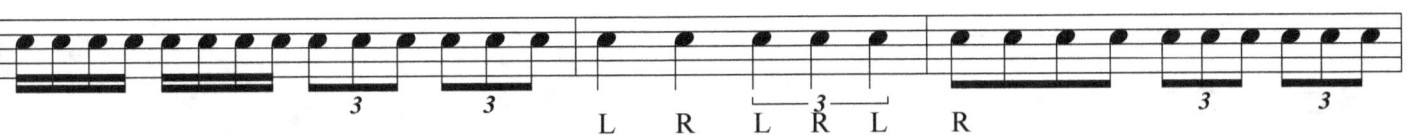
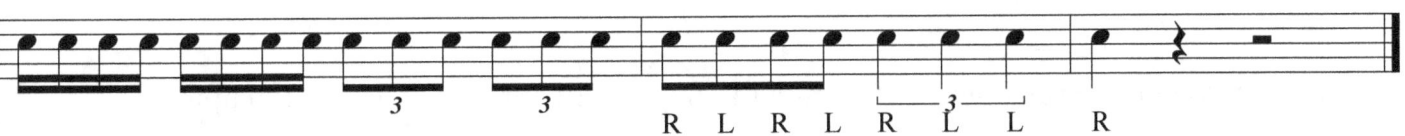

SEQUEL

DRUMLINE:
Once the line has mastered the timing of Gear Shift, it's time to add rolls into the process. This one became the default triplet roll exercise for me on competition days.

INDIVIDUALS:
Metronome, Metronome, Metronome!

GOALS
1. No accents
2. Push through the rolls

60 bpm	80 bpm	100 bpm	120 bpm	140 bpm	160 bpm	180 bpm	200 bpm

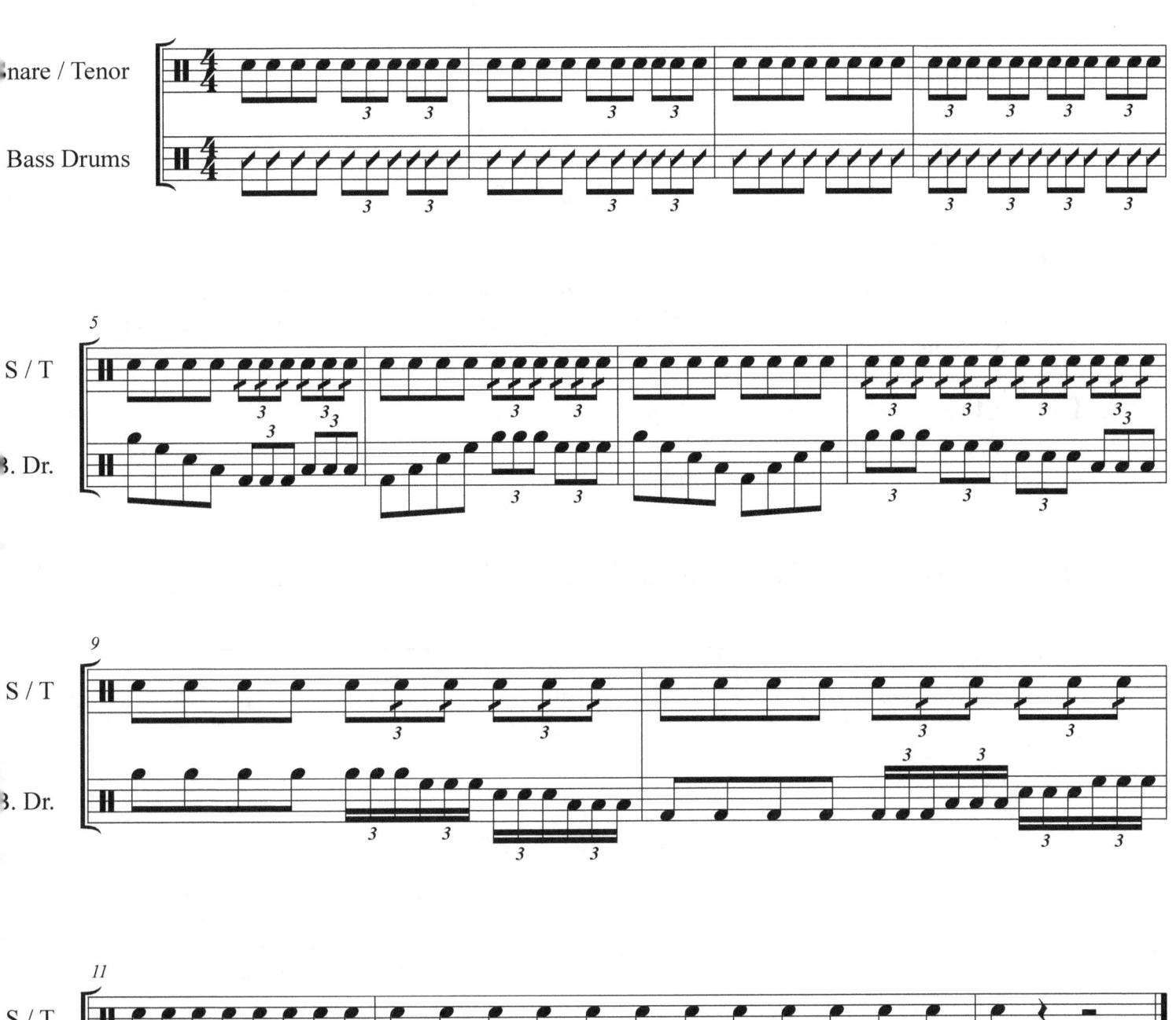

Stupid Left Hand

Drumline:
Time to work on everyone's weakness: that Stupid Left Hand!

Individuals:
Use this exercise to really develop your left hand. But be careful to maintain good consistency between the left and right hands. Take your time and really focus on building strength in your left hand.

Goals
1. Good left hand sound quality
2. Consistent sound between hands

60 bpm	80 bpm	100 bpm	120 bpm	140 bpm	160 bpm	180 bpm	200 bpm

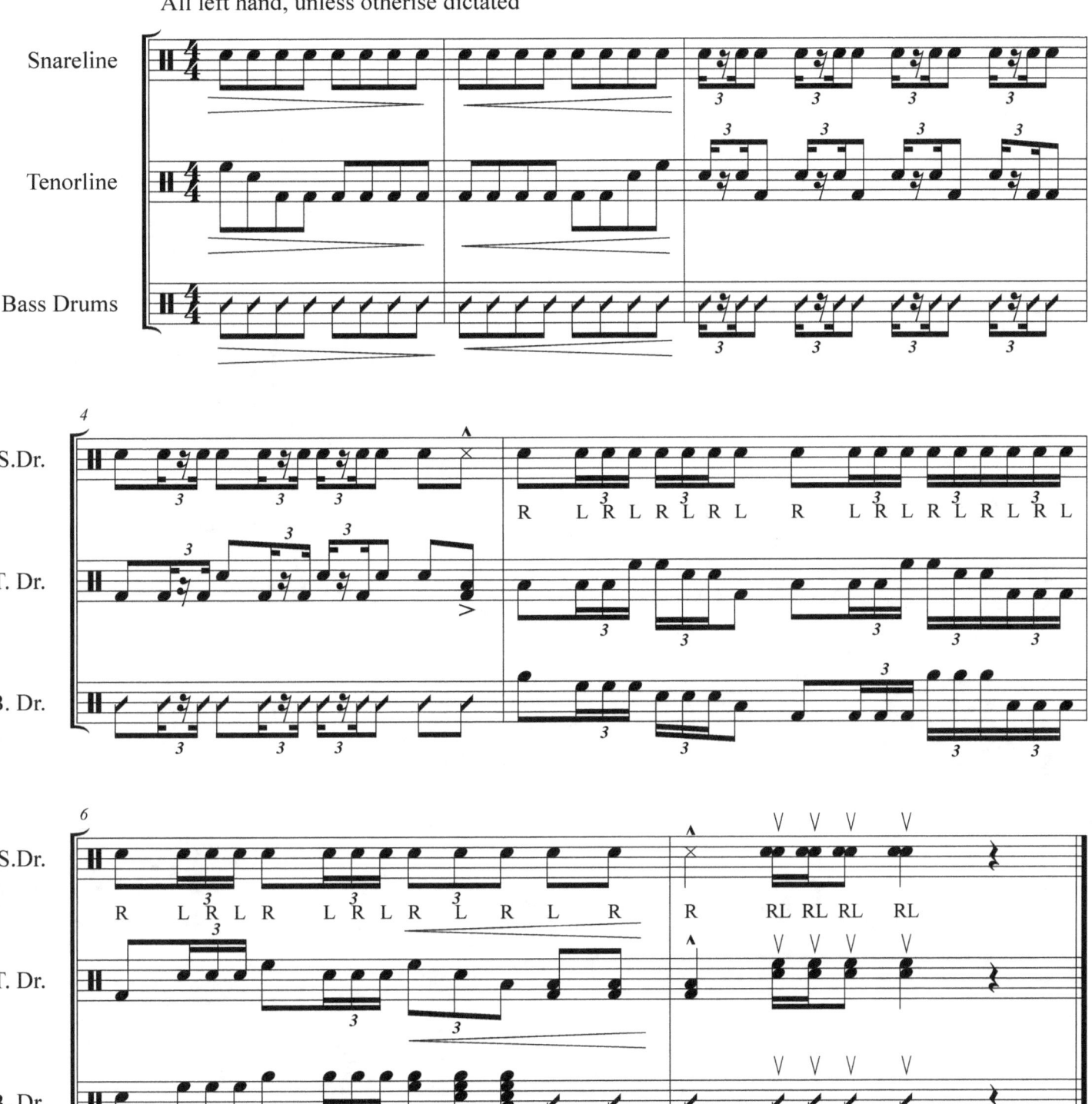

Cadences

Oscar

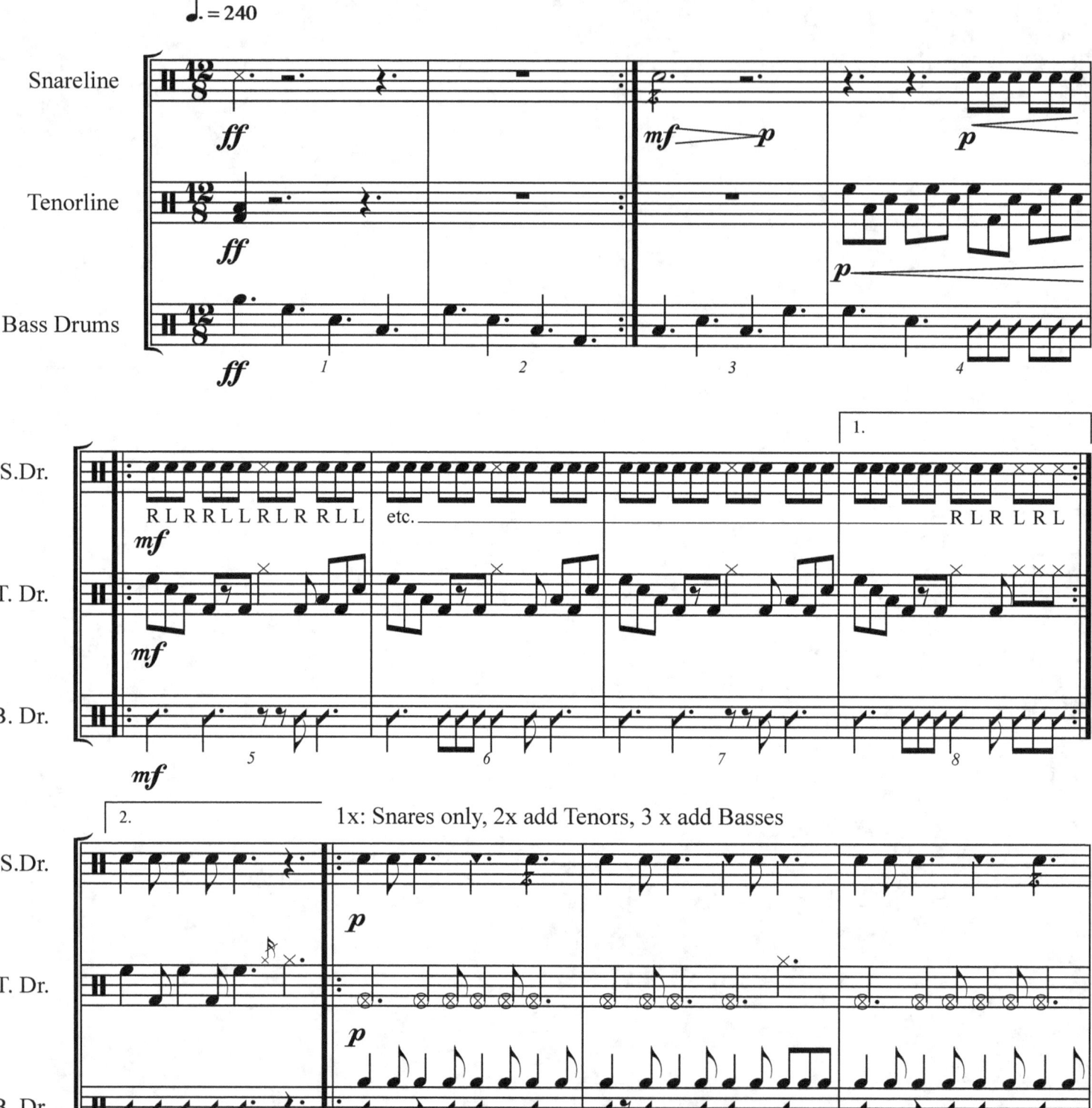

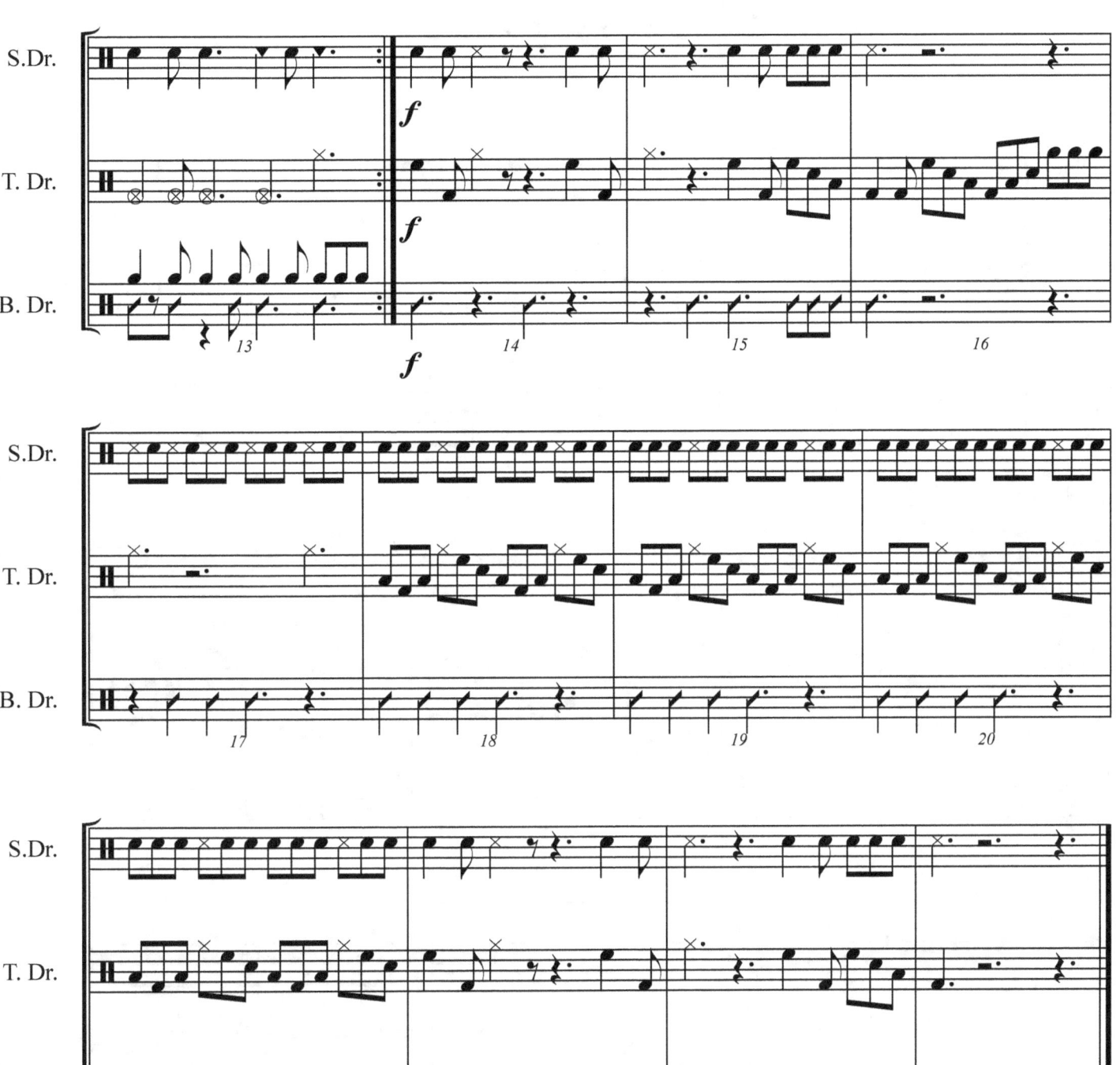

Neverland

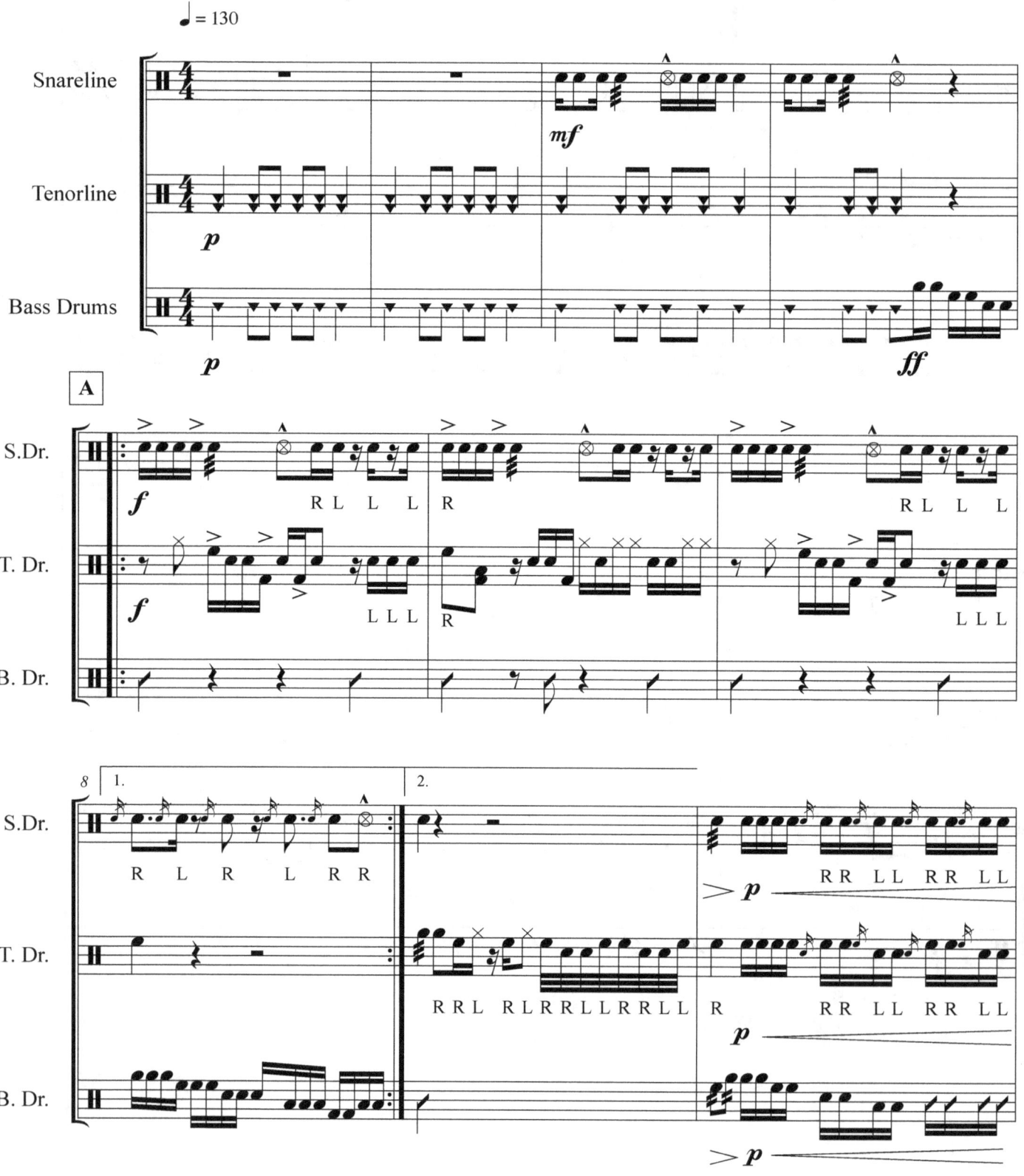

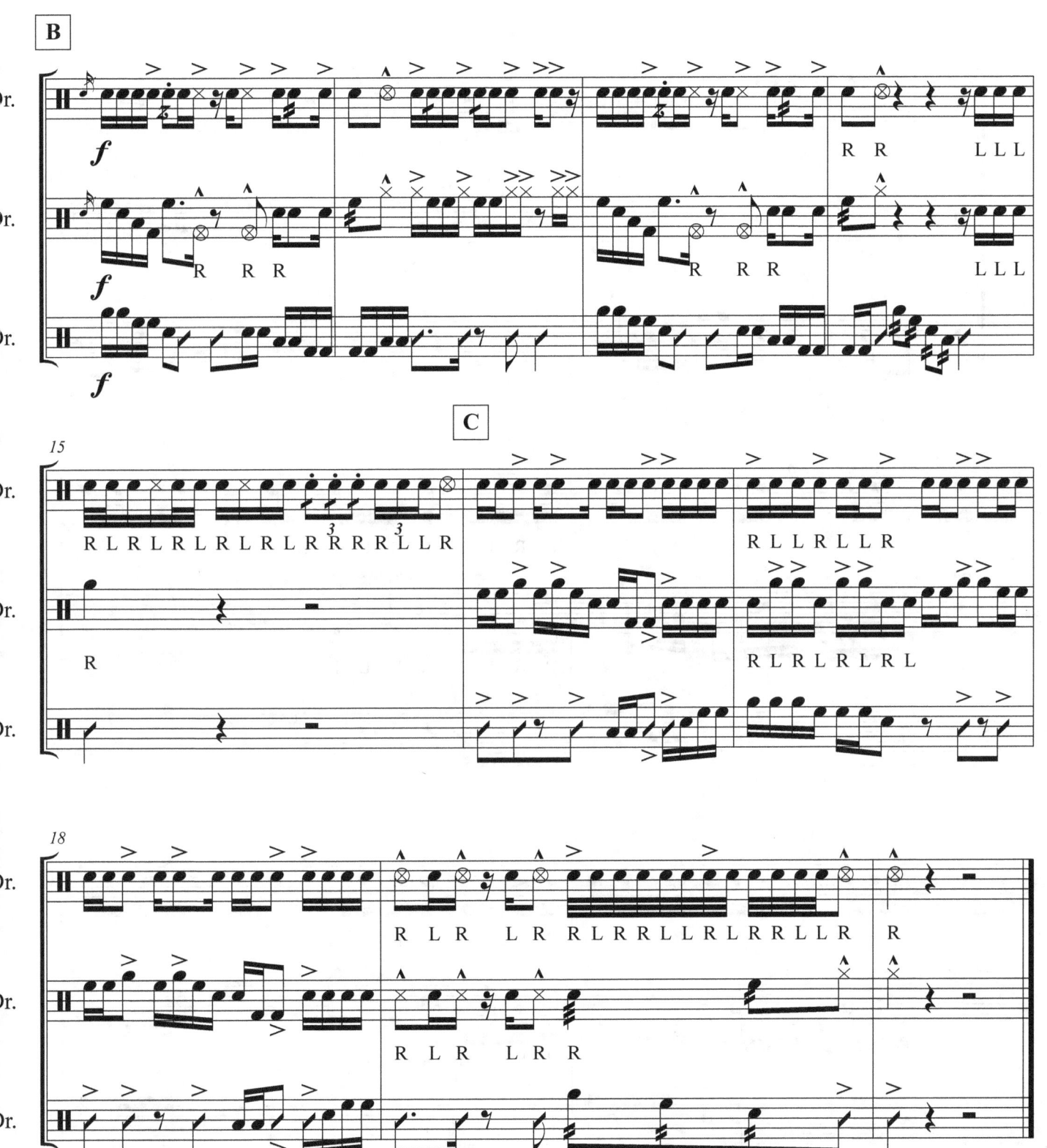

THE REMIX

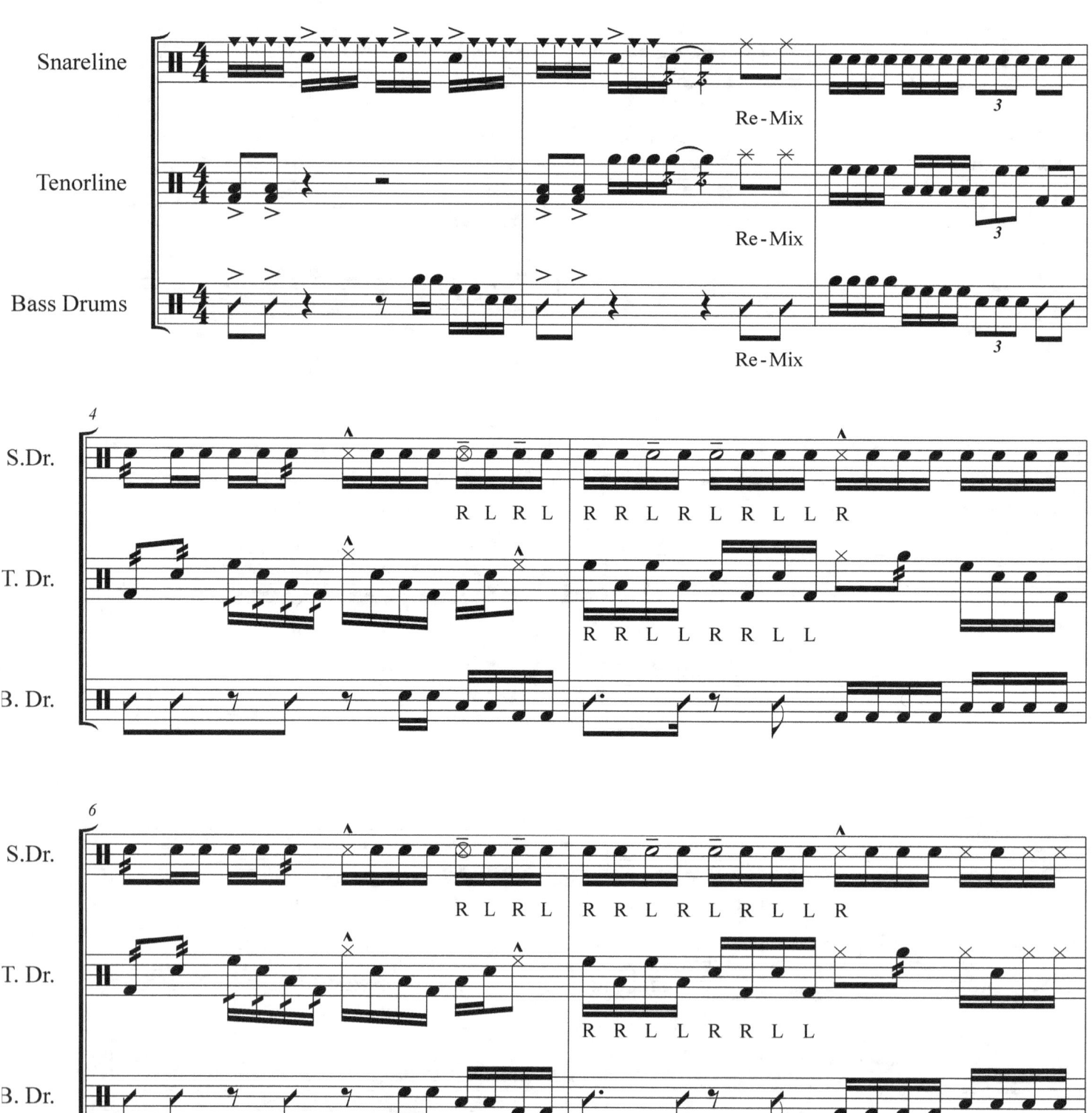

58

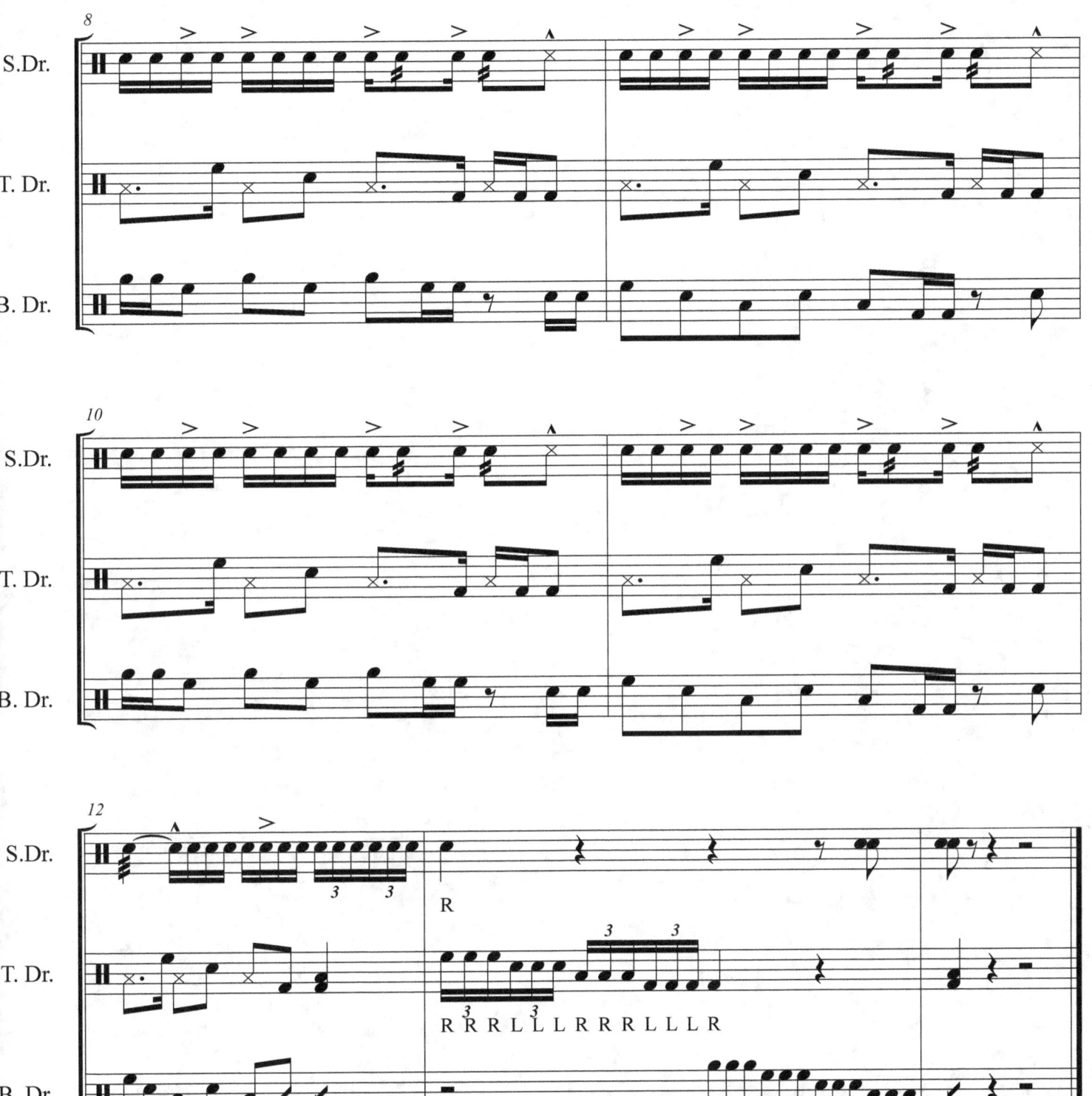

Solos

Velvet

Backbeat

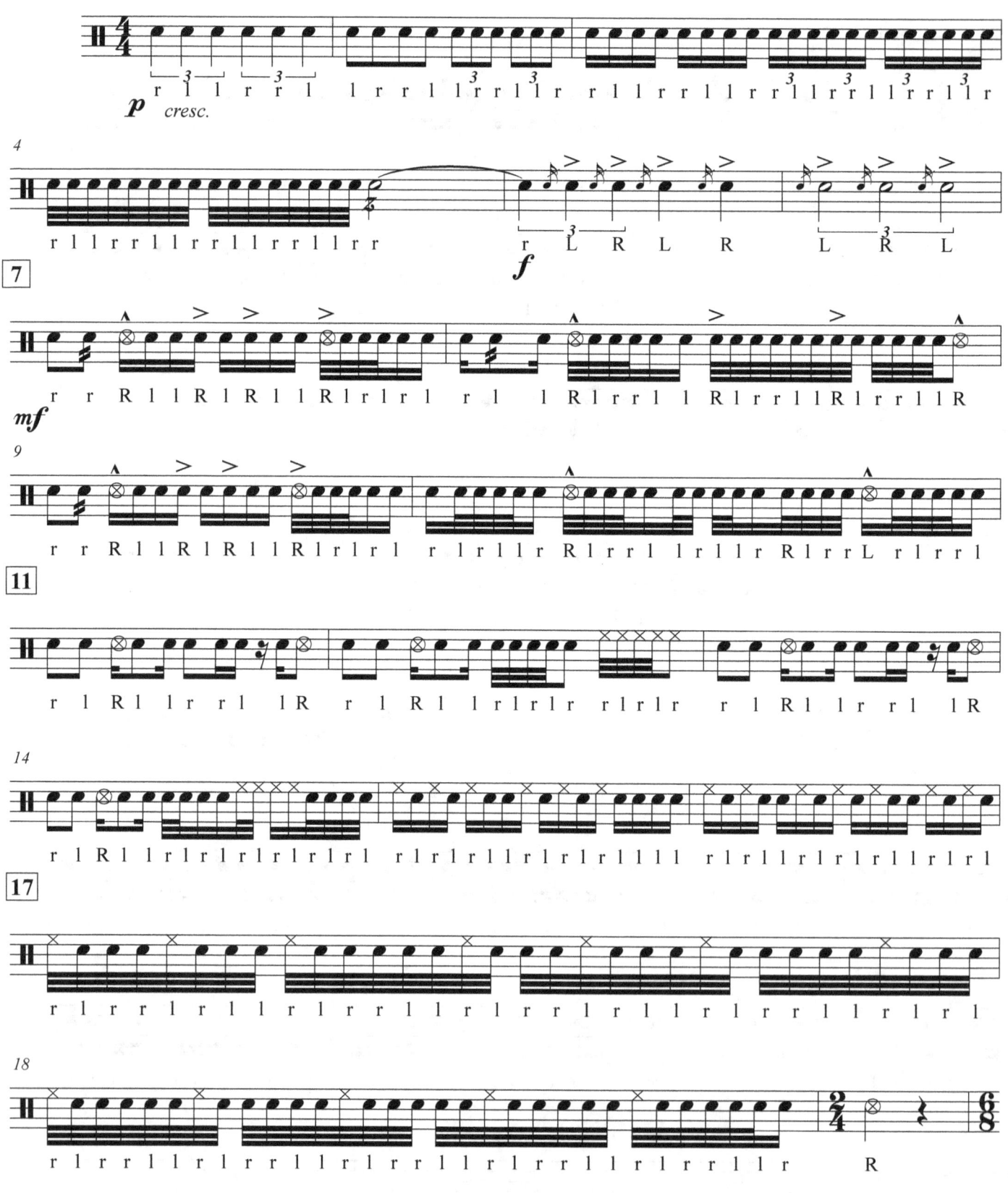

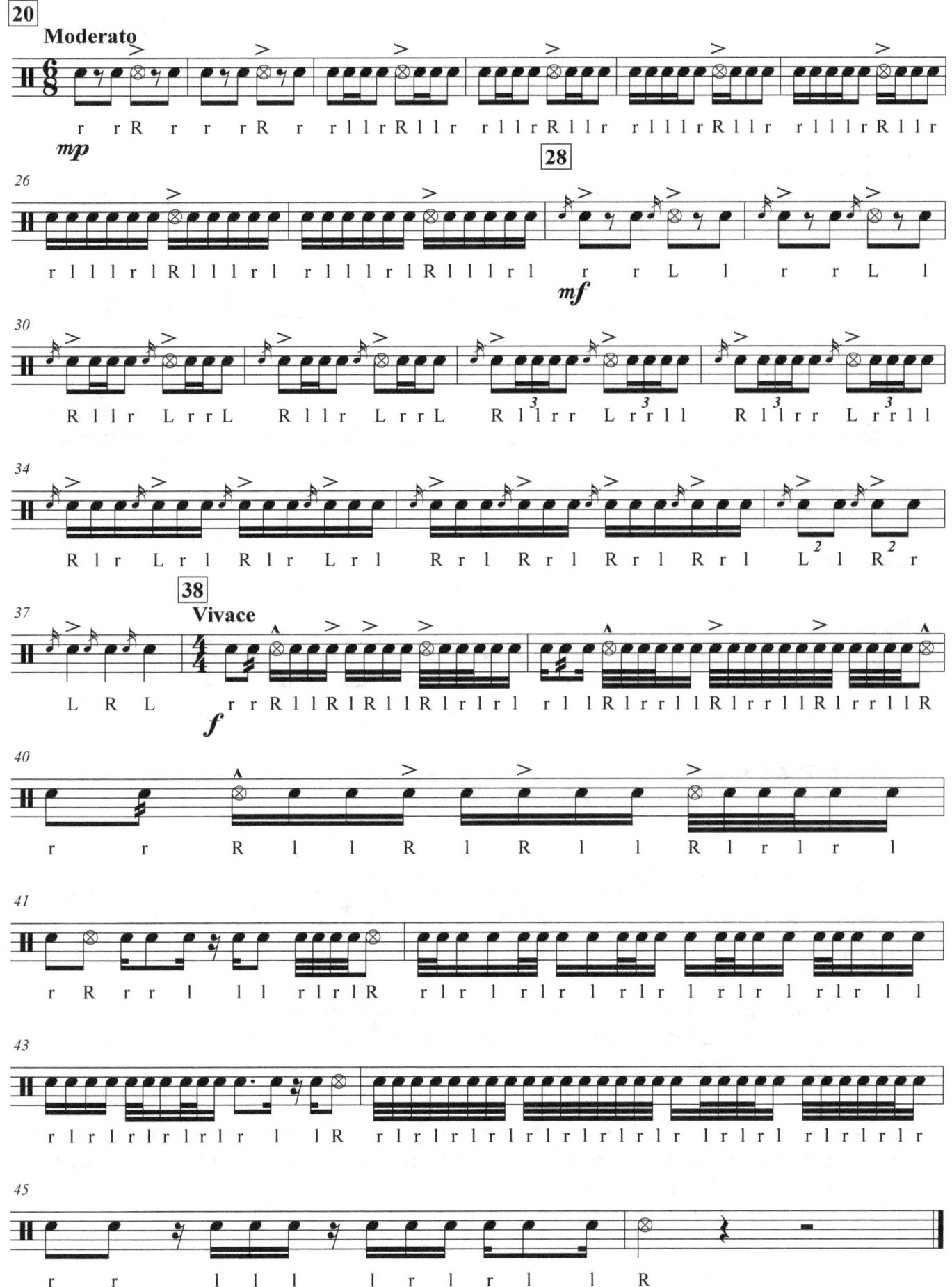

For a Lifetime
Dedicated to Tommy & Sonny Igoe

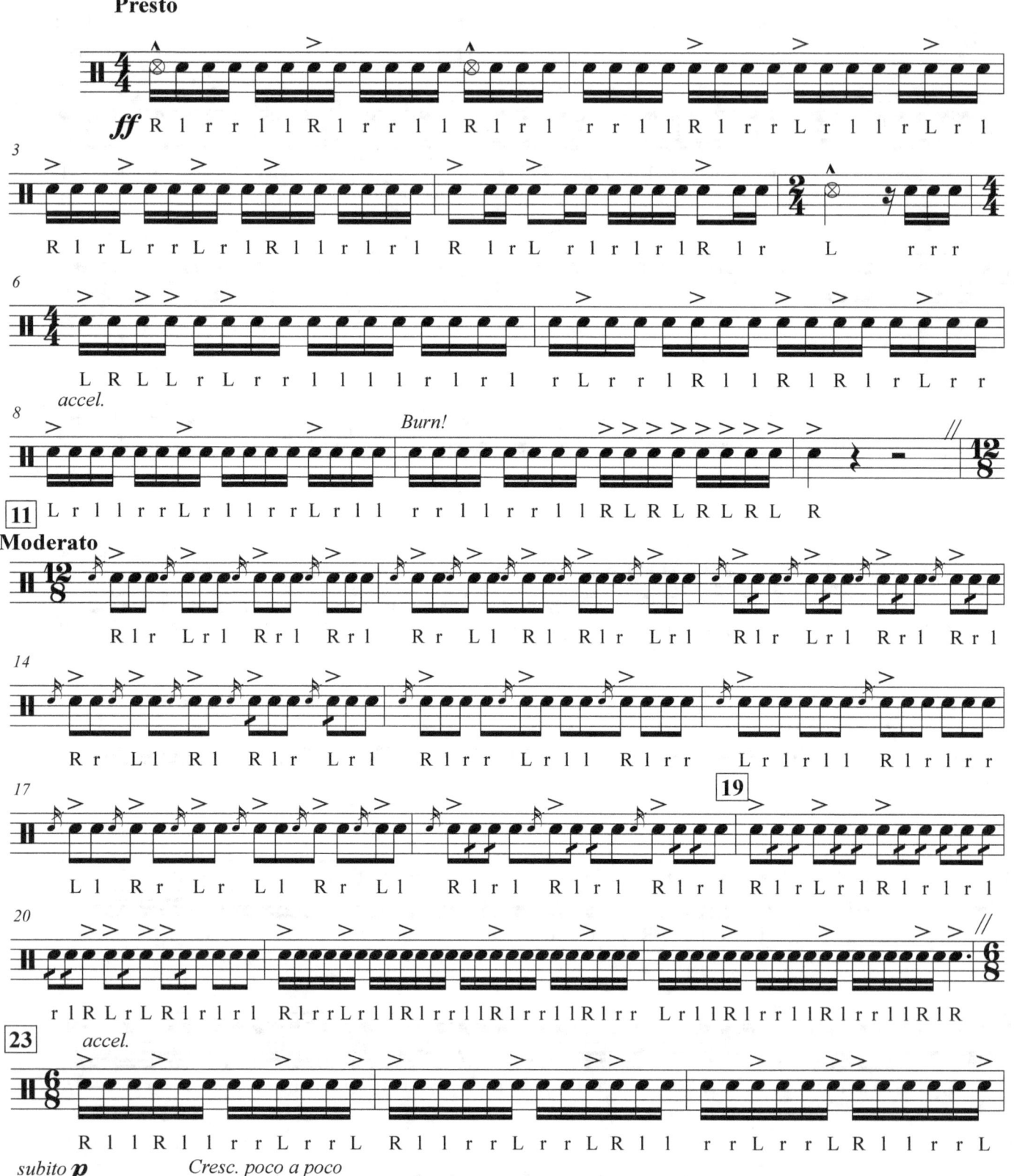

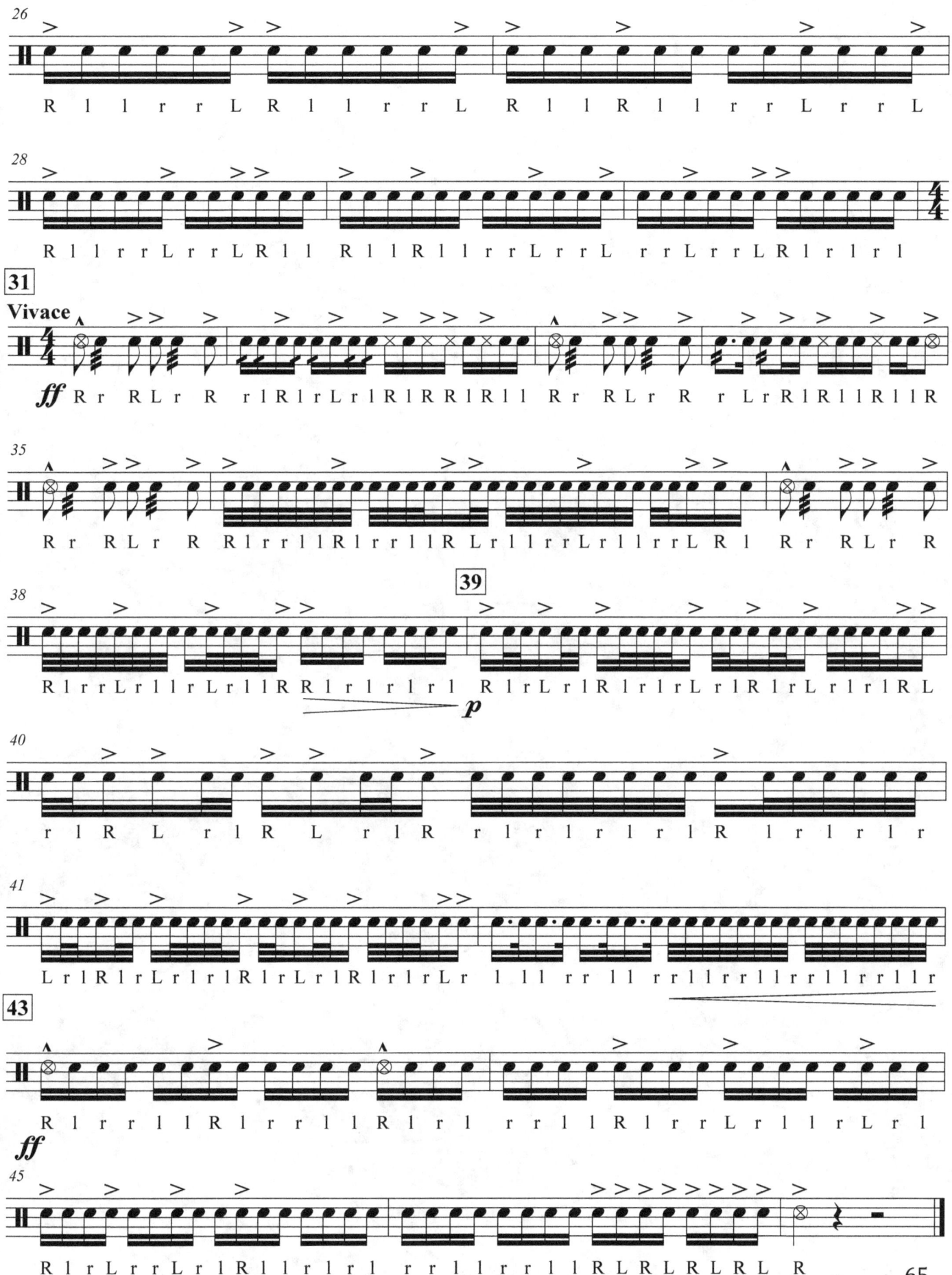

Appendix

Stroke Definition Worksheet

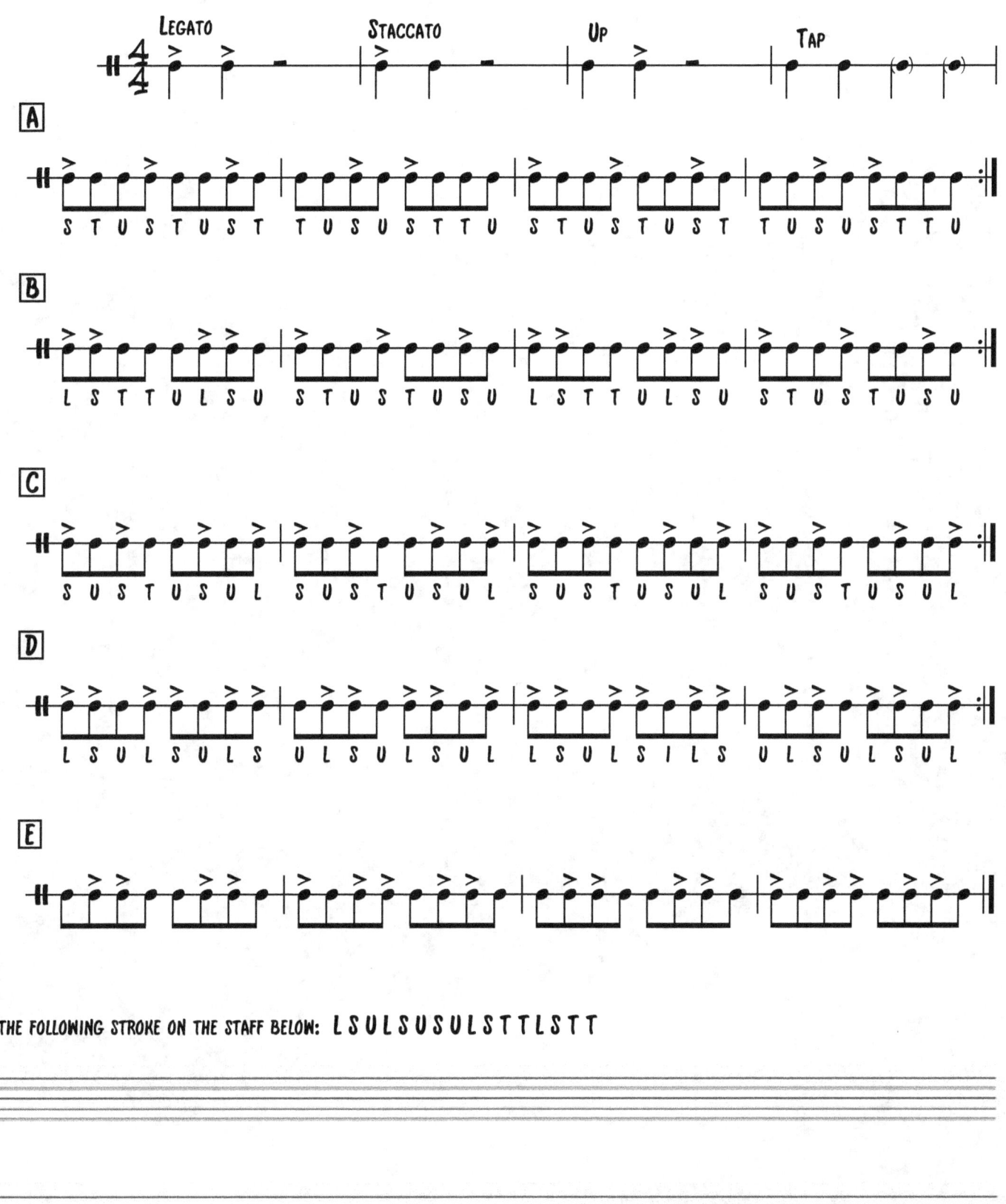

Notate the following stroke on the staff below: L S U L S U S U L S T T L S T T

About the Author

John Parker started playing drums and percussion, as most musicians do, in elementary school. After twenty-plus years, he is still addicted to the infectious feeling that only a solid groove can generate. "Drums and drumming are my passion." Now, John is excited to share that passion with the next generation of drummers.

John was educated for ten years at the Professional Drum School in Hutchinson, Kansas, directed by Ginger Zyskowski. There he learned his mastery of drum set along with his skills in marching, orchestral, and keyboard percussion. John's skills were further honed with Anthony DiSanza and Dennis Wilson at Kansas State University, along with Steve Hatfield in Wichita, Kansas.

Professionally, John has played with various performance groups. Most notably, these include stints with Hutchinson Symphony Orchestra and Crown Uptown Professional Dinner Theater. John's contemporary playing is on display each weekend when he occupies the drum throne at Newspring Church, where he works as a Music Associate in charge of all drums and drummers throughout the campus. Newspring is a venue that has given him the opportunity to participate in two recording projects and has educated him in modern stage performance technology.

John also works as a private instructor in the Wichita area where he teaches at Phatman Drums studios and at the Professional Drum School in Hutchinson. John has also coached with several drumlines in the area including a two-year stint at the Buhler school district.

A master of all drum set styles, orchestral percussion, and marching percussion, John is able to bring his wide breadth of experiences to each teaching situation. Tapping into that knowledge, students can be ensured that they are learning from a true professional, gigging musician.

John is endorsed with Mapex Drums, Sabian Cymbals, and Vic Firth Drumsticks.